1997 Biennial Exhibition

Lisa Phillips and Louise Neri

with a project by Douglas Blau

Whitney Museum of American Art, New York
Distributed by Harry N. Abrams, Inc., New York

This book was
published on the occasion of the

1997 Biennial Exhibition

at the Whitney Museum of American Art,
March 20-June 15, 1997

The exhibition is sponsored by Beck's.

Significant support has also been provided through an endowment
established by Emily Fisher Landau.

Support for educational programs related to this exhibition
has been provided by the New York State Council on the Arts.
Additional funds for the exhibition have been provided by
Austrian Airlines, and the National Committee of the Whitney
Museum of American Art.

Research for the exhibition and publication was supported by
income from an endowment established by Henry and Elaine
Kaufman, The Lauder Foundation, Mrs. William A. Marsteller,
The Andrew W. Mellon Foundation, Mrs. Donald A. Petrie,
Primerica Foundation, Samuel and May Rudin Foundation, Inc.,
The Simon Foundation, and Nancy Brown Wellin.

Cover image:
Wilbur E. Garrett
*Inky Investigates a Dollhouse and Rejects It
As Permanent Quarters: Too Small
National Geographic*, November 1956

ISSN 1043-3260 (Whitney)
ISBN 0-8109-6825-8 (Abrams)

© 1997 Whitney Museum of American Art
945 Madison Avenue, New York, New York 10021

Contents

This publication is made possible by a generous gift from Emily Fisher Landau.

Sponsor's Statement

As the largest and most continuous survey of contemporary art in the United States, the Whitney Museum of American Art's Biennial Exhibition is internationally renowned as a showcase for the most significant developments in American art. In breaking with traditional perceptions of nationality, generation, and artistic media, the "1997 Biennial Exhibition" promises yet again to innovate, surprise, and provoke.

Since 1985, the Beck's Arts Sponsorship Program has been a leading supporter of a broad spectrum of new and challenging international work in Britain. We have sought to encourage smaller independent galleries, festivals, and artist-run organizations, and have provided vital funds for rising visual and performing artists.

We are proud to inaugurate Beck's Arts Sponsorship Program in New York by sponsoring the Whitney Museum's "1997 Biennial Exhibition."

Axel Meermann
Marketing Director
Brauerei Beck & Co.
Bremen, Germany

Foreword

At a moment when American art is so widely appreciated, sought after, and collected, it is important to recall that the Whitney Museum was founded during quite different times. In the early decades of the century, American art was barely recognized by the individuals and institutions that comprised the art world. American art was, to say the least, an acquired taste, and an interest in it indicated a progressive attitude, a willingness to make judgments independent of the European traditions associated with the very idea of high art. Not surprisingly, the American art world mirrored the social and intellectual currents of the day—the conflict between modernism and the traditional academic establishment as well as the conflicting tendencies between internationalism and isolationism that defined American foreign policy between the wars. In short, American art was generally considered unworthy of the attention of serious art museums.

Working in the face of these conditions, the newly formed Whitney Museum of American Art began to encourage and support American art by exhibiting and collecting superb examples of the work of a relatively small group of artists active in the downtown New York scene. The Museum's sustained commitment to collect and exhibit the work of living American artists began with its Annual and later its Biennial Exhibitions.

This exhibition program has provided the Museum with the opportunity to acquire many of the masterpieces in our Permanent Collection; more important, it continues to generate a profoundly useful dialogue on the nature and condition of American art. Today this dialogue is framed in a expanded context. As art itself mirrors the complexity of the times in which we live, the dialogue reaches well beyond the confines of the art world. American art no longer needs to be championed simply for its nationalistic qualities, and the Museum senses no compelling need to promote the American art market or any particular school. In fact, as the century draws to a close, the old battle between the modern, pre-, and postmoderns is largely irrelevant. And, perhaps most significant, American art and American artists now participate in an overtly global dialogue which reflects a profound change of attitude in the century's waning years.

This does not mean, however, that the Whitney today is less concerned with the idea of American art, or with the shifting values that define American art of our time. Rather, it means that in the late nineties the Whitney Museum is no longer easily definable, and that its exhibitions—especially the Biennial—need to be structured in order to explore and expose more meaningful and consequential aspects of American art and culture.

As in each Biennial since 1991, one Whitney curator has been given curatorial control of the exhibition. In 1997, Lisa Phillips accepted this challenge and responsibility. Phillips and her chosen curatorial partner, Louise Neri, U.S. editor of *Parkett* magazine, have worked for the past two years on an exhibition that is perhaps the most focused and carefully constructed in the series' history. Like many recent Biennials, the "1997 Biennial" does not pretend to survey the totality of American art of this moment. Instead, it explores certain linked dichotomous notions that captured the curators' interest during the long months of review and consideration.

With a carefully determined intellectual and aesthetic center, the "1997 Biennial" presents a critically focused overview of contemporary activity in the United States. Though some of the artists are US residents but not American citizens, they all share in attitudes and concerns that the curators feel are axial in American art of the past several years. And, as in several recent Biennials, the group of artists selected is multigenerational as well as diverse in many other ways.

The Museum is grateful to Phillips and Neri for their dedicated field work—they visited more than five hundred studios across the United States and reviewed slides submitted by several thousand artists—and for their willingness to construct from that research an exhibition distinguished by its clarity, intelligence, and beauty.

We are pleased that the "1997 Biennial" has as its primary corporate sponsor Beck's, the German brewers and distributors. This marks the company's first major American sponsorship, and we are proud to have been selected as the recipients of Beck's support. On behalf of the Museum's Board of Trustees, we thank Beck's for its confidence and generosity.

We are enormously grateful to Emily Fisher Landau, Vice President of the Whitney's Board of Trustees, for her endowed support of the Museum's signature exhibition program. Mrs. Landau's deep understanding of the importance of the Biennial to the Museum's varied audiences and especially her willingness to act on this understanding continue to distinguish her patronage.

David A. Ross
Alice Pratt Brown Director

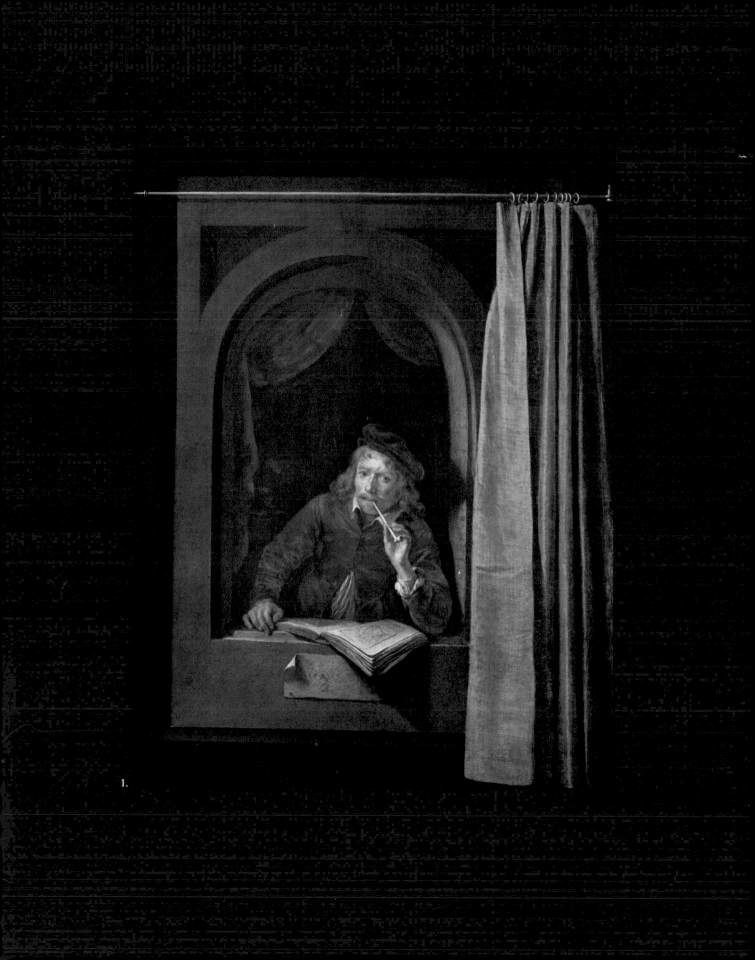

1.

3.

4.

6.

7.

8.

9.

10.

11.

12.

13.

14.

15.

16.

17.

18.

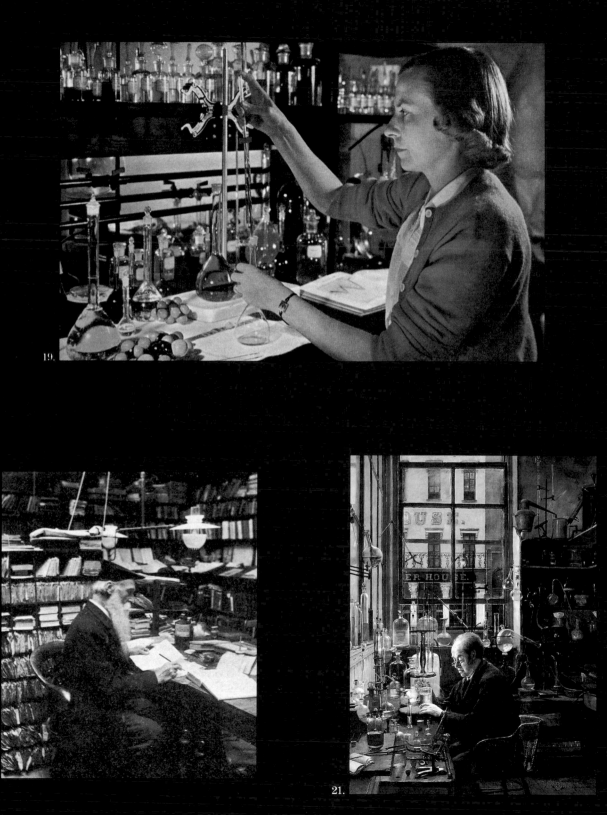

19.

20.

21.

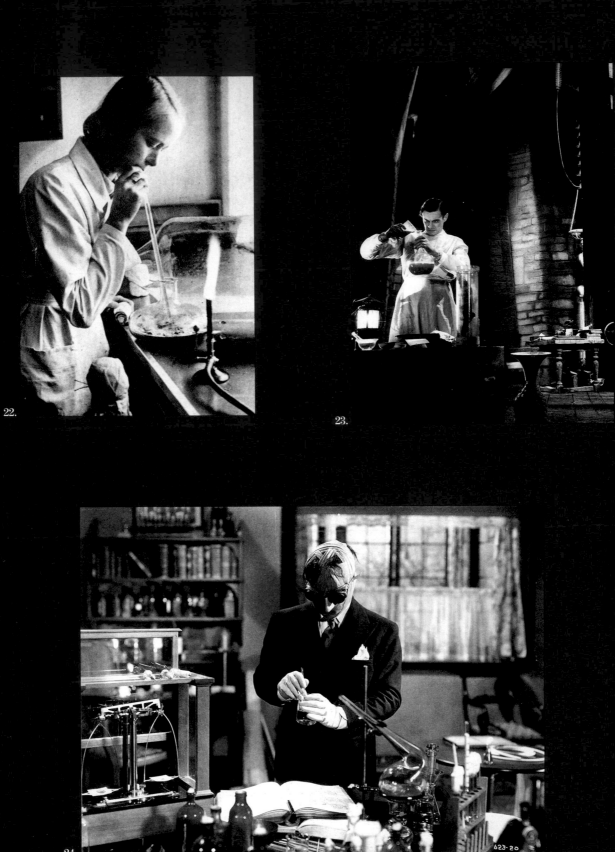

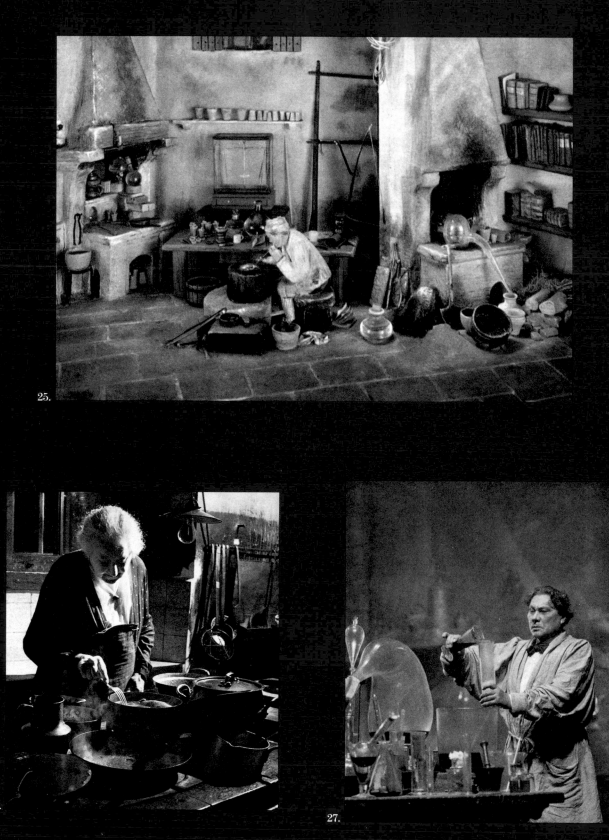

25.

26.

27.

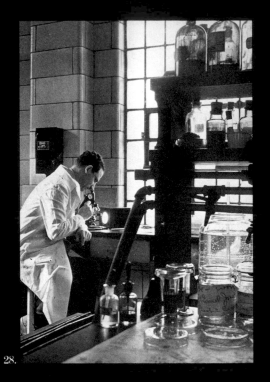

28.

29.

30.

31.

32.

33.

34.

35.

36.

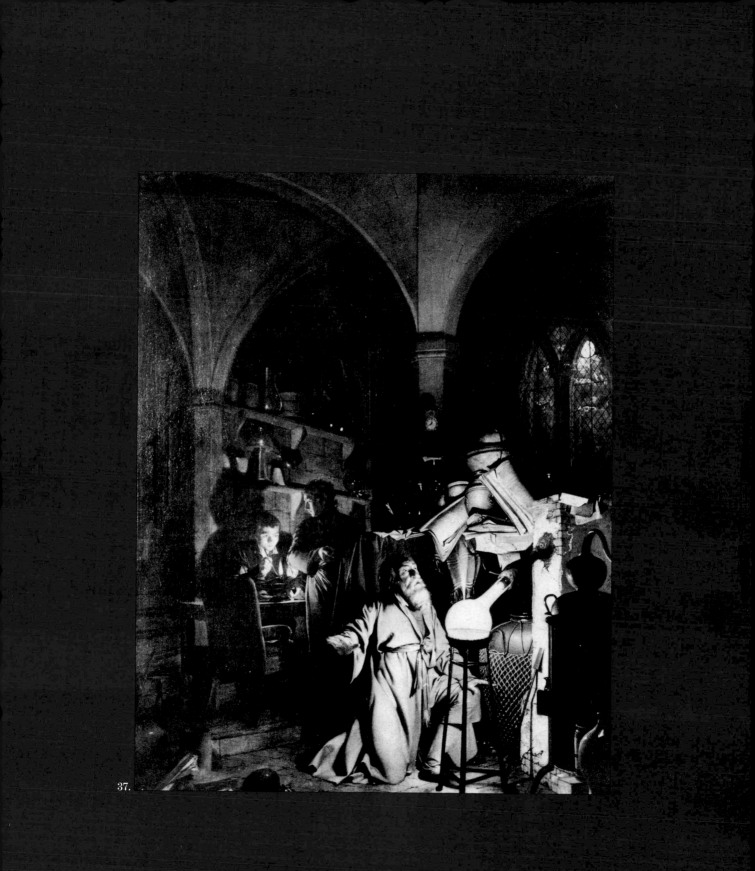

37.

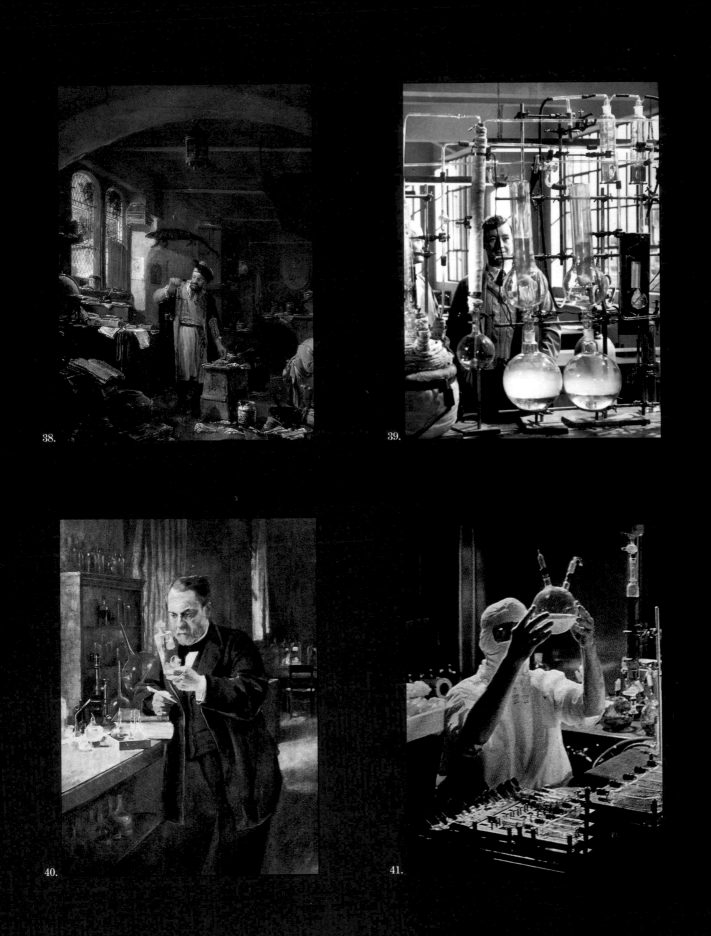

38.

39.

40.

41.

42.

43.

45.

46.

47.

48.

49.

50.

51.

52.

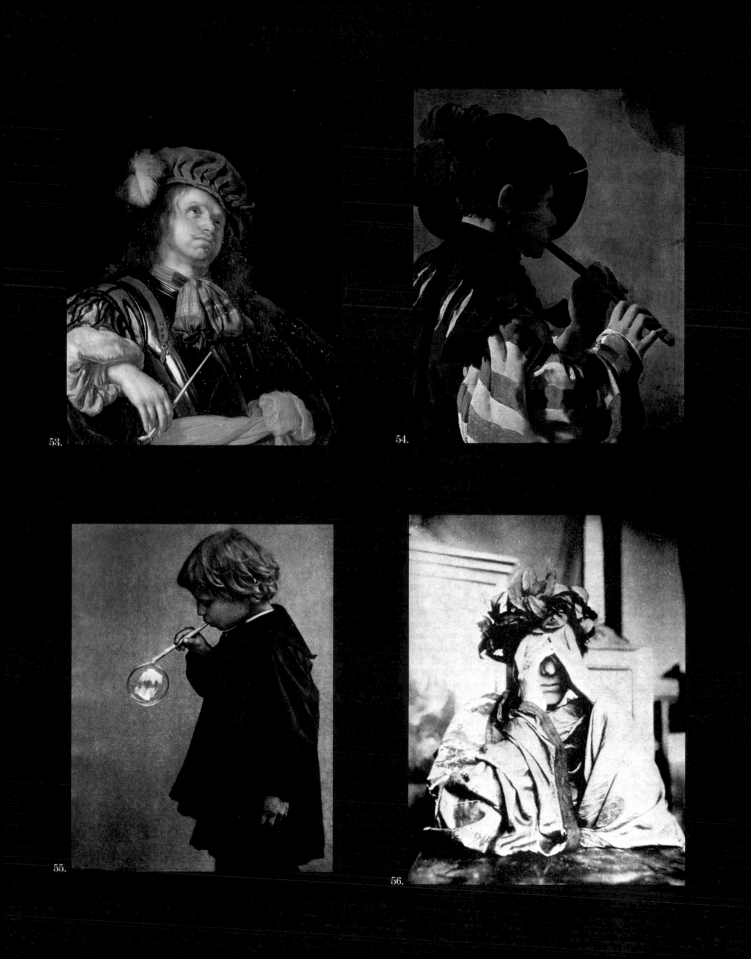

53.

54.

55.

56.

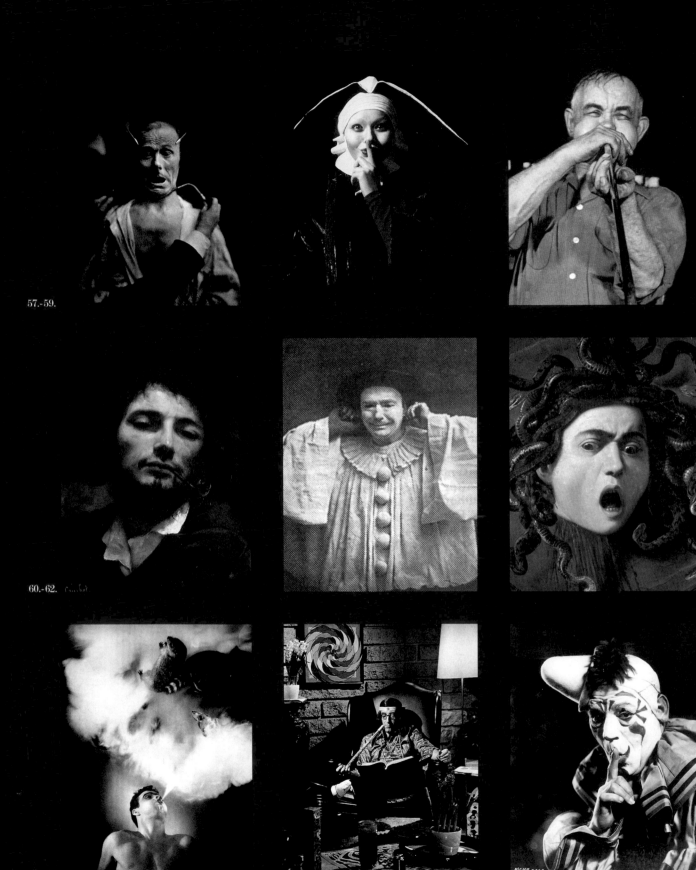

57.-59.

60.-62. Courbet

63.-65.

 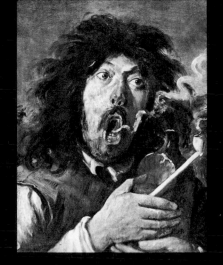 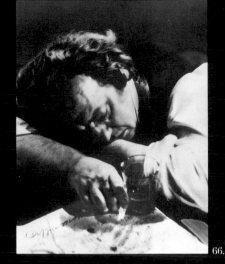

66.

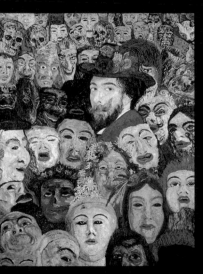 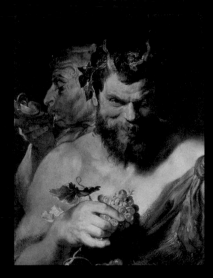

69.

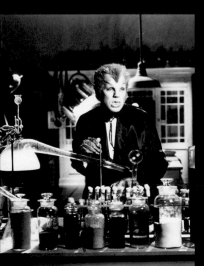 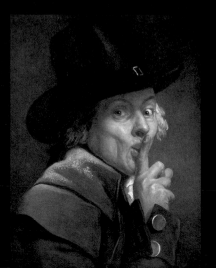 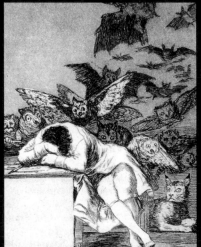

72.

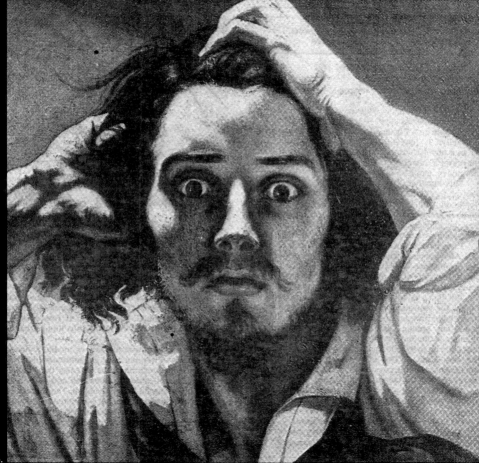

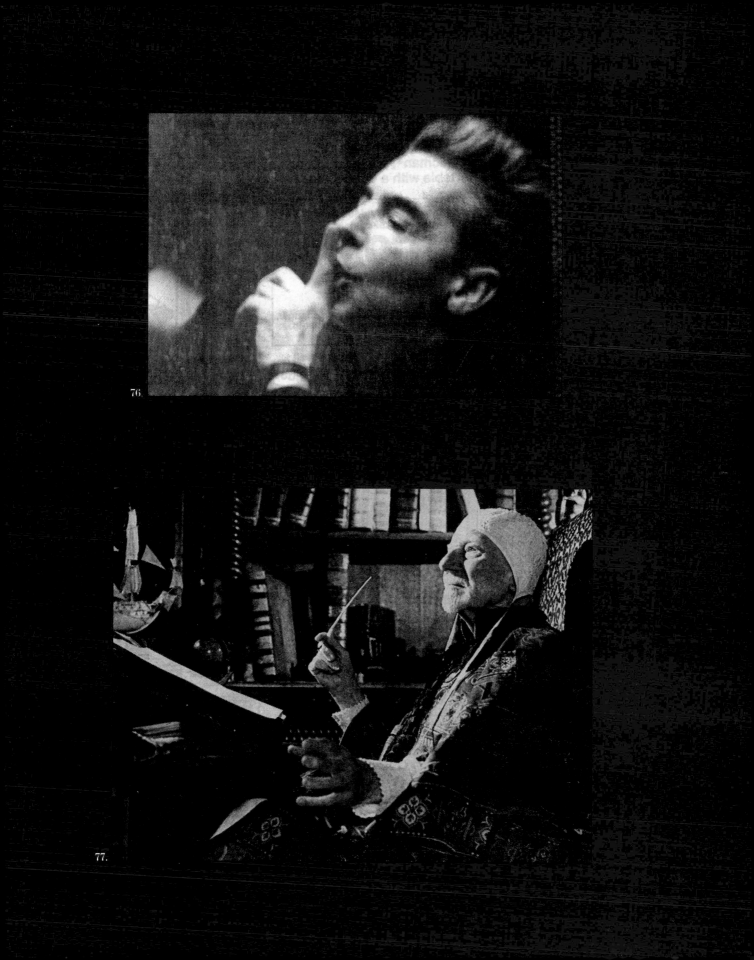

76.

77.

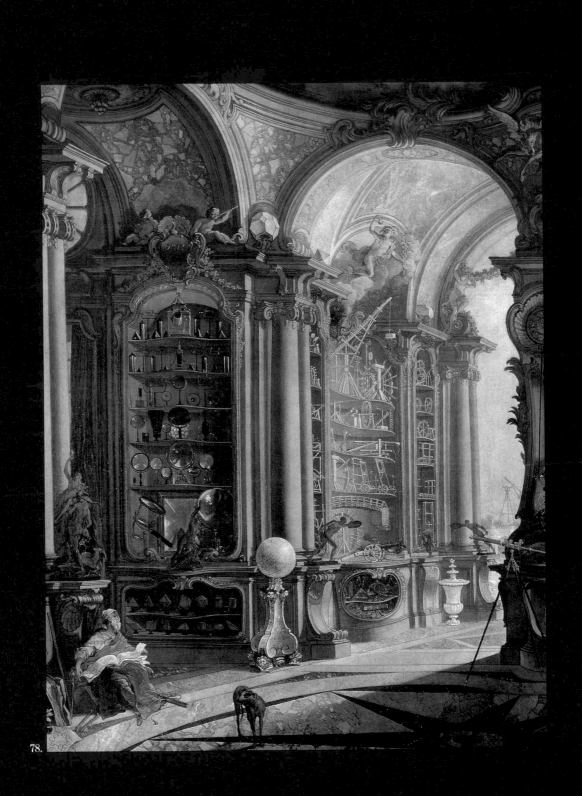

78.

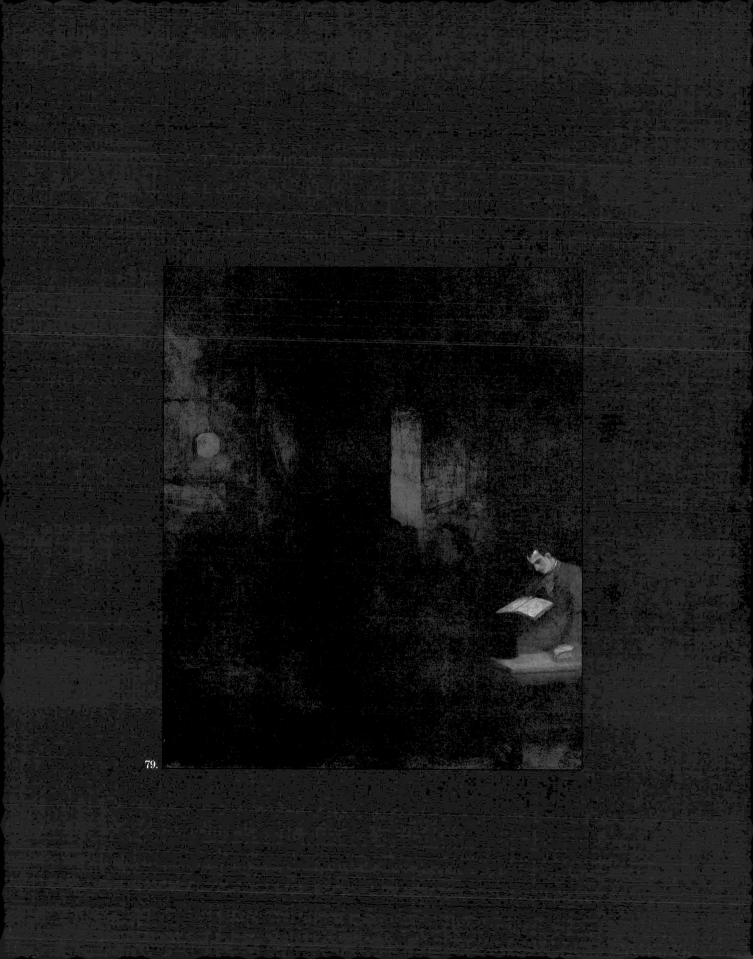

79.

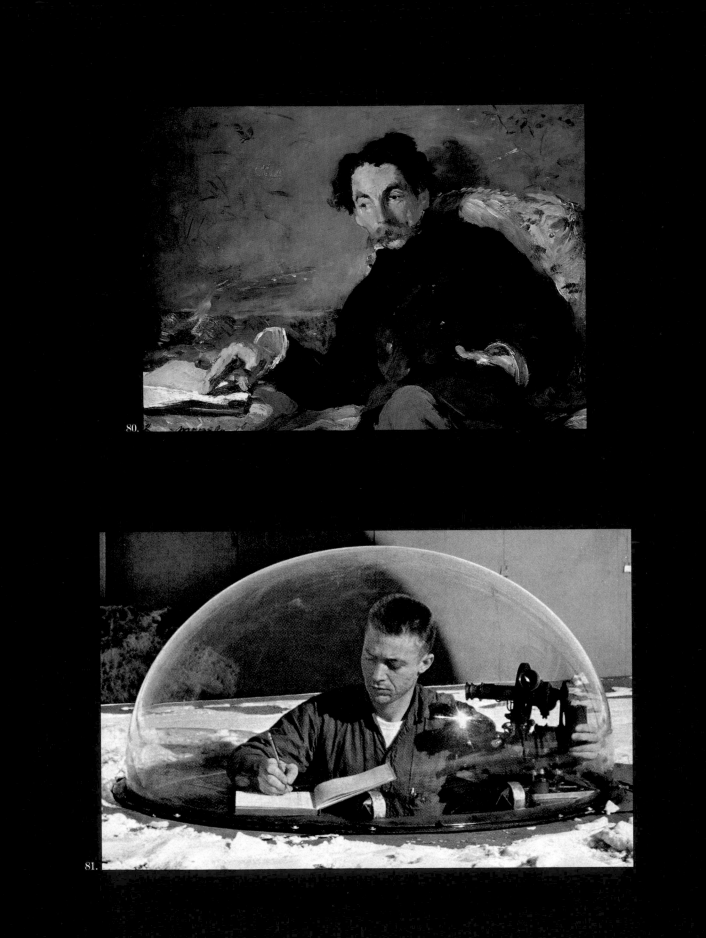

80.

81.

83.

Douglas Blau *The Studio*

1. Gerard Dou, *Self-Portrait*, c. 1654, Rijksmuseum, Amsterdam. **2.** *Happy Youth of China*, June 1955, Chinese Youth Publishing House, Beijing. **3.** *(Faun)*. **4.** *Irkutsk: A Photo Album*, 1986, Archive of the Irkutsk Regional Historical Museum. **5.** George F. Watts, *Choosing (Portrait of Dame Ellen Terry)*, c. 1864, National Portrait Gallery, London. **6.** Il Veronese (Paolo Caliari), *Industry* (detail), 1576-1577, Doges' Palace, Venice. **7.** Justin N. Locke, *At the Botanic Garden, in the Shadow of the Capitol Dome...*, September 1948, National Geographic Magazine. **8.** Jean-Honoré Fragonard, *Self-Portrait*, c. 1797, California Palace of the Legion of Honor, San Francisco. **9.** Erle C. Kenton, *Island of Lost Souls*, 1932, Paramount Pictures. **10.** Edmond Van Hove, *(The Apothecary or Sage)*, c. 1896, (5 15.02) *The Studio*, London. **11.** *The Face of Finland*, 1948, Kustannusosakeyhtio Otava, Helsinki. **12.** Raoul Walsh, *The Thief of Bagdad*, 1924, United Artists. **13.** Vittore Carpaccio, *St. Jerome in his Study* (detail), c. 1502, Scuola di San Giorgio degli Schiavoni, Venice. **14.** *(Culture)*, c. 1990, New York Times Magazine. **15.** Donald McBain, *Potato Fruit* (detail), August 1953, *National Geographic Magazine*. **16.** *Harry Graus's Garden* (detail), April 1957, AP/Wide World Photo. **17.** *Cadfael: The Leper of St. Giles*, 1994/1995, Mystery!/Public Broadcasting Service. **18.** *Kandinsky in his Paris Studio*, 1936, Roger-Viollet, Paris. **19.** Willard R. Culver, *Detective Dye Reveals Impurites in Oils, Drugs, Cleaning Fluids*, December 1951, National Geographic Magazine. **20.** *James Murray in the Scriptorium, at Work on the OED*, c. 1888, Oxford University Press. **21.** Henry Alexander, *The Laboratory of Thomas Price* (detail), 1886, Metropolitan Museum of Art, New York. **22.** *The Face of Finland*, 1948, Kustannusosakeyhtio Otava, Helsinki. **23.** James Whale, *The Bride of Frankenstein*, 1935, Universal Pictures. **24.** James Whale, *The Invisible Man*, 1933, Universal Pictures. **25.** *Constedt's Laboratory in 1757, a Diorama*, c. 1965, Science Museum, London. **26.** *(Elixir)*, c. 1958. **27.** Rex Ingram, *The Magician*, 1926, Metro-Goldwyn-Mayer. **28.** Eliot Elisofon, *Flash Illumination*, 1941, *U.S. Camera*. **29.** Howard Sochurek, *(Georges de la Tour)*, c. 1971, *National Geographic Magazine*. **30.** Rouben Mamoulin, *Dr. Jekyll and Mr. Hyde*, 1931, Paramount Pictures. **31.** F.W. Marnau, *Faust*, 1926, UFA. **32.** G.W. Pabst, *Secrets of a Soul*, 1926, Neuman Film. **33.** Anthony A. Boccaccio, *Laboratory Twister* (detail), April 1972, *National Geographic Magazine*. **34.** Bruce Dale, *...Genetically Engineered Bacteria...*, September 1976, National Geographic Magazine. **35.** Rembrandt van Rijn, *Faust in his Study*, c. 1652, Rijksmuseum, Amsterdam. **36.** David Teniers the Younger, *The Village Doctor*, c. 1665, Palais des Beaux-Arts, Brussels. **37.** Joseph Wright of Derby, *The Alchymist, in Search of the Philosopher's Stone, Discovers Phosphorus, and Prays for the Successful Conclusion of his Operation, as was the Custom of the Ancient Chymical Astrologers*, 1771/1795, Derby Art Gallery. **38.** Thomas Wijk, *The Alchemist*, c. 1665, Hermitage, St. Petersburg. **39.** Alexander Mackendrick, *The Man in the White Suit*, 1951, Ealing Studios. **40.** after Albert Edelfelt, *Pasteur in his Laboratory*, c. 1885. **41.** *Research Facility, Bethesda Maryland* (detail), February 17 1958, *Life Magazine*. **42.** *(Perfume)*, c. 1989, *Avenue Magazine*. **43.** *(Sampling)* (detail), c. 1991, *New York Times Magazine*. **44.** Arie deZanger, *Wines and Spirits*, 1968, *Time-Life Books*. **45.** August Makart, *Österreich*, 1960, Verlag des Österreichischen Gewerkschaftsbundes, Vienna. **46.** Stephen Weeks, *I, Monster*, 1970, Amicus. **47.** Matthias Stomer, *Cavalier Lighting a Pipe from an Oil Lamp*, c. 1639, (#46A, 1.17.92) Sotheby's, New York. **48.** John Loengard, *Dr. Presnell Pouring LSD-25*, March 29 1963, *Time Magazine*. **49.** Murillo (Bartolomé Esteban), *A Young Man Drinking*, c. 1645, National Gallery, London. **50.** Ken Howard, *Full Gallop*, October 19 1995, *New York Times*. **51.** Jean-Baptiste Siméon Chardin, *Soap Bubbles*, c. 1734, Los Angeles County Museum of Art. **52.** *Holland as It Is*, 1952, Lankamp & Brinkman, Amsterdam. **53.** Willem van Mieris, *Self-Portrait* or *The Smoker*, c. 1700, (#135, 6.2 88) Christie's, New York. **54.** Hendrick Terbrugghen, *The Flute Player*, 1621, Gemaldegalerie, Kassel. **55.** Heinrich Kuhn, *Child Blowing a Soap Bubble*, c. 1910, (#259, 5.24.82) Sotheby's, New York. **56.** Fernand Khnopff, *Sister*, c.1890, Archives de l'Art Contemporain en Belgique, Brussels. **57.** Dr. Duchenne de Boulogne and Adrien Tournachon, *Terror*, 1854, École Nationale Supérieure des Beaux-Arts, Paris. **58.** Federico Fellini, *Fellini's Casanova*, 1976, Casanova Company. **59.** B. Anthony Stewart, *Glass Blower* (detail), April 1955, National Geographic Magazine. **60.** Gustave Courbet, *Portrait of the Artist or The Man with the Pipe* (detail), c. 1848, Musée Fabre, Montpellier. **61.** Nadar (Gaspard-Félix Tournachon), *Charles-Dominique-Martin Legrand* (detail), 1855-1859, Musée d'Orsay, Paris. **62.** Caravaggio (Michaelangelo Merisi da), *Medusa* (detail), c. 1596, Uffizi, Florence. **63.** George Platt Lynes, *Blanchard as Boreas*, 1939, Robert Miller Gallery, New York. **64.** Hy Averback, *I Love You, Alice B. Toklas!*, 1968, Warner Seven Arts. **65.** Herbert Brenon, *Laugh, Clown, Laugh*, 1928, Metro-Goldwyn-Mayer. **66.** Jean Delville, *Portrait of Mrs. Stuart Merrill*, 1892, Private collection. **67.** Adriaen Brouwer, *Self-Portrait* or *The Smoker*, c. 1635, Louvre, Paris. **68.** Abel Gance, *The Life and Loves of Beethoven*, 1936, Generales Productions. **69.** James Ensor, *My Portrait Surrounded By Masques*, 1899, Private collection. **70.** Peter Paul Reubens, *Two Satyrs*, c. 1625, Alte Pinakothek, Munich. **71.** See 5. **72.** Stuart Walker, *Werewolf of London*, 1935, Universal Pictures. **73.** Joseph Ducreux, *Self-Portrait* or *Silence*, c. 1788, Maurice Segoura Gallery, New York. **74.** Francisco de Goya y Lucientes, *Caprice 43: The Sleep of Reason Produces Monsters* (detail), 1797/1799, Prado, Madrid. **75.** Gustave Courbet, *Portrait of the Artist* or *The Desperate Man*, 1841/1843, Private collection. **76.** Robert Lackenbach, *Herbert Von Karajan*, c. 1989, Black Star. **77.** Peter Greenaway, *Prospero's Books*, 1991, Allarts/Cinda/Penta Film. **78.** Jacque de Lajoue, *The Cabinet of Monsieur Bonnièr de la Mosson* (detail), c. 1750, Sir Alfred Beit, Bart. **79.** Gustave Courbet, *The Painter's Studio; A Real Allegory Determining a Seven Year Phase in My Artistic Life* (detail), 1855, Musée d'Orsay, Paris. **80.** Edouard Manet, *Portrait of Stéphane Mallarmé*, 1876, Musée d'Orsay, Paris. **81.** David S. Boyer, *(Perfect Vacuum)*, September 1957, National Geographic Magazine. **82.** Joel Coen, *Barton Fink*, 1991, Rank/Circle. **83.** Henri Le Secq, *Still Life*, c. 1855, International Museum of Photography at George Eastman House, Rochester. **84.** Jean-Baptiste Siméon Chardin, *The House of Cards*, c. 1737, National Gallery of Art, Washington D.C.

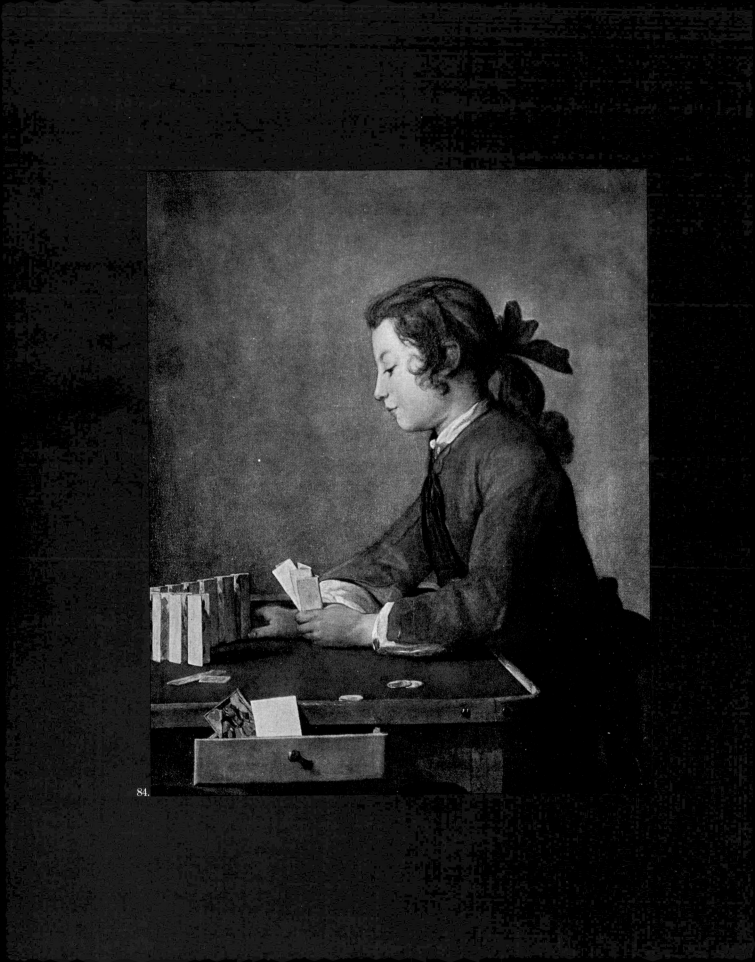

84.

Inside-Out

A Conversation Between Lisa Phillips and Louise Neri

The first step in the process of organizing the "1997 Biennial" was my decision to invite Louise Neri to work with me as a curatorial partner. Breaking with precedent, I invited an outsider to participate as a co-curator because I wanted to have a dialogue with someone who has a different perspective on American art and culture. Neri, the respected US editor of the international journal Parkett, *is not only outside the institution; she was raised in Australia and has had extensive experience working abroad. The organizing structure of the exhibition, then, set up a dialectic between inside and outside—an important dynamic that we pursued throughout the process and that was critical to our conception of the exhibition.*

Our first discussions revolved around a consideration of large survey exhibitions. We had seen several together and discovered that we shared certain views about them. We questioned how to make an extensive exhibition meaningful; how to satisfy the expectations of a diverse audience, while maintaining some kind of internal philosophical integrity. To some extent, the Biennial is a lightning rod of cultural change: different sectors of the art-going public have different expectations—from amateurs who want an overview of what's going on, to local professionals who want to critically assess the level of cultural vitality, to foreign professionals who want to be informed about new developments in American art. We agreed that we didn't want to make a sampler, and set about determining a matrix of motivations drawn from our observations of contemporary artists at work. Our collaborative structure required that we make very strong cases for each artist in terms of the overall parameters that had been established through our discussion and dialogue.

The inside/outside dialectic has been central to our imaginings about the show: the contrast between Wonder Bread America and its Puritan underpinnings and the sea changes brought about by the growing ethnic ascendancies of the twentieth century; and between official culture and subversive subcultures. In defining "American" art, we elected to stay within the fifty states, exploring the rich cultural diversity that exists within the country and recognizing the fact that there are many foreign artists domiciled in the United States who are affected by their experience of living here and who make substantial contributions to the local culture and imagination. Conversely, we acknowledged the fact that many American artists show their work more regularly and extensively in

other parts of the world, and we committed ourselves to bringing some of that work to a local audience.

In the course of our research, we focused our attention on an emerging generation of artists working at new heights of complexity and ambition. At the same time, we revisited more established artists whose work continues to confound our expectations. It is clear that all these artists share certain primary obsessions about being in the world. We attempted to draw some of them out with the following questions.

What does it mean to be an artist at the end of the millennium? Has the role of the artist changed? Have the conditions of making art changed? How does an artist build a cosmology or tell a story that is private and individual and yet resonates with a more public reality? How can an exhibition, in turn, tell the stories of these private worlds?

LP: In considering these questions, we've confronted the creative tensions that exist between inside and outside—individual and institution, private cosmology and social reality, imagination and reality. We've observed how artists explode the seamless fictions of normalcy by revealing cracks in that seamlessness.

LN: As background, we also thought a lot about the asylum—not so much in terms of the madhouse, but rather in the original sense of sanctuary: the sanctuary of the imagination, and how this might relate to the museum as a sanctuary for art and its place in (a rather antagonistic) social reality. And following this, the idea that art is a place to construct a world, a place between the self and the world that the viewer can enter too.

We've asked ourselves many times whether there are "millennial tendencies" in the work we have looked at and, paradoxically, what we've ended up locating are the continuities in art rather than the ruptures, the depths of artistic motivation rather than its passing symptoms, the state of poetic contradiction to which artists consign themselves—postmodern deconstruction seems very far away!

LP: I think that after an intensive period of looking at the world through a deconstructive lens, a whole generation is now sensitized to the contradictions that surround us. The analysis and questioning of structures of power, racial and sexual politics, the writing of history, who is speaking through whom, who is looking at whom, and so on—the "encoding" of our mediated world—has now become a normative way of viewing the world and absorbing information. For

instance, in *The New York Times* recently, there was an article about a man who consults for large media companies on the trends and habits of young people. He reported that kids prefer to channel-surf rather than stay with one television program, enjoying the connections they can draw between things and deciphering the codes in different kinds of programming. After fifteen years of deconstructive practice, we are moving into a different phase. And artists are able to understand and visualize cultural mythologies and contradictions in ways that are neither didactic nor programmatic. The limits of analysis are also keenly felt, and there is a sense that no matter how much you understand something there will always be much that is resistant to explanation and description.

LN: I read a beautiful analogy somewhere about taking a clock apart to find out what time is. You might find out how the clock is made, but time itself remains an ineffable thing. The process of taking apart and putting back together describes a mechanism, but it doesn't reveal the central metaphysic. Art is an endless intersecting loop between imagination and reality, possibility and improbability, fact and fiction. If you tried to undo it and separate the imaginary from the real, you would just be left with the pieces, which are less important than the sum.

LP: Yes, there is a certain pleasure in embracing the absurdity or uncanniness of the chaos and turbulence in the world. And there is a greater awareness of these frictions than previous generations had. We accept that as the reality of the world, which is a sort of unreality—the surreal of the everyday.

LN: This is particularly evident in film and video, where the line between what is fake and what is real is erased due to filmmaking's inherently artificial nature.

LP: Whether in film, or video or photography, the photographic image plays a really important role because of its unique ability to convey "reality" and "truth"—the photograph is a literal trace of something, and, as we know, it is also a highly constructed thing.

LN: Yet despite the infinite possibilities of visual manipulation and hypertext that the computer now offers, we have been drawn here to photographers who do not exploit the photograph further than minor retouchings, who are dealing with a certain level of vérité in terms of the exigencies of staging—whether it's Sharon Lockhart waiting for extraordinary atmospheric conditions, or Paul Shambroom exploring Ballardian environments, or Philip-Lorca diCorcia finding drama in the humdrum of the street by means of a flash-trap. These photographers dramatize reality by framing it rather than simulating it.

LP: In the seventies there was a movement away from so-called "straight" photography and toward the obviously constructed image, where backdrops were painted and scenes were staged and artificiality was emphasized. In contrast, I think much of the work here plays on a fine line between document and fiction and acknowledges that the dichotomy between "straight" and "art" photography is a fallacy.

LN: Now artists use their environment as backdrop in their process of distilling reality. Photography is always concerned with time and its compression or attenuation or dramatization, but this is really pushed to maximum effect in the photography we present here. This heightened awareness and densification of image returns to the idea of the surreal of the everyday. Which is perhaps why surveillance seems to be a central preoccupation not only in photography, but in film and video as well—that process of obsessively tracking and revealing what might and does happen in everyday life...

LP: Isolating and distilling particular moments of strangeness out of that flow of normal everyday experience....

LN: ...then creating a strong ambient effect by weaving it together seamlessly in the editing process with historical footage, constructed historical footage, documentary footage, constructed documentary footage, and completely constructed fiction—as in Abigail Child's film *B/side*.

LP: It's a vérité document intercut with what is obviously a staged narrative.

LN: But watching it for the first time you can't be sure where it is set even though you've probably been there. Is the setting familiar or alien, local or foreign? Is it somewhere you've seen on news reports or out of a car window? Is it in a war zone or is it in a city at peace? It certainly looks as if it is under siege.

LP: You could compare that to the Bureau of Inverse Technology's *Suicide Box*, which is a seemingly factual documentary about the Golden Gate Bridge as the number-one suicide site in America. It uses a combination of real and fictionalized statistics and staged surveillance footage to create something utterly convincing. It's very possible that something like this might happen and we might not be aware of its frequency and exact proportion—that sort of *Ripley's Believe It or Not* idea of an astonishing fact right under your nose that you're not aware of but that is completely plausible.

LN: Child's and BIT's films are highly ambient in terms of how they permeate your subconscious, recalling, recombining the things we've seen,

the things we know, with things less familiar. With *Suicide Box*, a million statistics flood your brain when that one particular statistic is mentioned. All these things become part of the mix.

LP: There's a strong relationship between ambience and surveillance. And that may be why surveillance is of such interest to artists—because it is about all of those peripheral sounds and images that come into the frame. There's a fixed frame that things move in and out of.

LN: The works we present deal with the poetics of surveillance rather than its politics, how you actually experience the process of observing. They're not confrontational, rather, they creep up on your consciousness.

LP: Take the photographs of John Schabel, for instance, in which he uses a telephoto lens to capture images of unsuspecting people in airplane windows, people you could never really see that way from outside. You identify with the person observed—the person inside, encapsulated in the plane, waiting in that suspended state before takeoff. It's a poetic image of alienation that we've all experienced but which has never been visualized in quite this way. They look like portrait miniatures, soft-focused and timeless.

LN: Child's film works to similar effect. It collapses the subjective into the objective, cutting back and forth between the protagonist's interior world of emotion and memory (linear, filmed in black-and-white) and the loud blur of an urban slum (a collage of grainy video bites). This visual experience is underscored by an ambient soundtrack taken from radio broadcasts, snatches of things familiar and foreign, static, frame noise. Constructed ambience reframes or recombines much of your perception of what it is to be outside when you're inside. The experience of any person walking a block in a contemporary megalopolis today comes through the work of Lari Pittman, Philip-Lorca diCorcia, Dan Graham, in many of the films, in the real-time, audiovisual mixes of Cultural Alchemy's "illbient" experiment, SoundLab. All the improbable collisions described in the Surrealist adventure have now become a way of life for us. This recovery of the irrational suggests a kind of counterdeconstructive move by artists who are proving once again that art can, and should, be something astonishing.

LP: Take the urban experience of Chris Burden's *Pizza City*, a work that he has been involved with for the past seven years. It's a model of a city and of his personal obsession—a huge agglomeration of models from all different parts of the world and historical periods, built on a ground of makeshift tabletops and organically structured around zones of activity. He has compared *Pizza City* to Los Angeles as a city that is constantly expanding and mutating at the edges, always

changing. That's true of so many modern cities that expand to encompass towns and villages around them that were once isolated little hamlets, now incorporated into this expansive structure.

LN: *Pizza City* is dense but sprawling, ideal from a distance but totally disturbing close-up—a heterotopic utopia. It's what you would get if you combined Los Angeles with New York. Like the exhibition itself, which points to the drastically different but equally extreme realities of New York and Los Angeles.

LP: New York has been the reigning cultural center in America, but Los Angeles has come into its own as a powerful creative center in the last decade, which is one of the things that is underscored by the exhibition. Los Angeles has a very strong art community which primarily revolves around a cluster of extra-ordinary art schools. While there are many enterprising young dealers there, Los Angeles is not a market center. It is a production center. Strong links have been established with European institutions and curators and much of the work now bypasses New York and goes straight to Europe. The need for community is more acute in Los Angeles because of the geographic expanse, and the marginalization of culture in a one-industry town.

LN: Are you saying that these conditions affect the individual artist?

LP: Los Angeles is a powerful environment, different from New York in so many ways—the light, the vegetation, the horizontal sprawl, the specific multi-cultural mix, the tension of natural disasters, the dominance of the entertainment industry. How could you not respond to those factors if you were living and working there? Its horizontality suggests sprawling installations; its openness and the relative isolation of artists contribute to the freshness and iconoclastic nature of the work. That isn't to say that there aren't shared concerns between East and West Coast artists, but the form West Coast art takes is distinctive. A lot of the artists, even though they work slowly, have very high production values, which in some way reflects being in a town whose central industry is Hollywood. Take Jennifer Pastor and Paul McCarthy. They use theatrical and special effects and stage-set-building techniques to create fixed hallucinations—something that can't quite be described—that go back to the sense of wonder mentioned earlier.

LN: Yes, many of them create the frame of film, whether it's Martin Kersels designing melodramatic soundtracks for everyday activities, or the physical residue of Paul McCarthy's performances, which are themselves brutal and messy satires of American myths. But then, isn't all of North American culture largely dominated by Hollywood movie and media culture?

LP: Sure, it's an overwhelmingly pervasive influence in this country that

has been felt in art at least since Andy Warhol, if not earlier. But I'm thinking more in terms of the physical manifestation, the scale and the theatricality of a lot of the work in Los Angeles; elsewhere I think you see it reflected more in terms of subject.

LN: It's true that, in some ways, art production may have become analogous to film production in terms of the expenditure and compression of time, research and development, production and technique, editing and presentation, but, in fact, artists increasingly oppose the division of labor that mass culture perpetuates by becoming self-sufficient, one-person industries.

LP: Well, I think that's a really important development we've noticed, and it may have something to do with the drastic change in the market that occurred around 1990, and the release from the tyranny of supply and demand. I think there has been a really positive effect from the change: artists can spend more time developing their work and don't feel that same kind of pressure to produce. There's more time to perfect and refine and explore. I think that was a real problem a decade ago, that there often wasn't that time. Obviously there were other benefits...

LN: That the creative climate was euphoric?

LP: Yes, it was euphoric and there was tremendous support and that was very encouraging. Stimulating in another sense. However, there have always been exceptions—artists who chose to work slowly, maybe sacrificing attention or economic gain. Some of these iconoclasts, like Vija Celmins and Chris Burden, are role models for a new generation. For instance, now we see a lot of artists spending six months developing one photograph or a year working on a sculpture. There's less production and more process, more research and development and refinement.

LN: Yes, and sometimes these tasks are Sisyphean, either involving forays into new materials or techniques or projects that might be so open-ended that they are almost impossible to accomplish. Like The Wooster Group's obsessive technical elaboration of the original 35mm footage that was shot for *Wrong Guys*. They have worked the material up into a dense and delirious layering of sound, image, and emotion until it almost falls apart. I don't know if there is any constant ratio in terms of how much film a filmmaker shoots and then discards in the editing process, but there is probably a close correlation between that process and what a lot of plastic artists are doing. There is an enormous amount of time being spent simply getting to the point at which a work can begin to be made.

LP: Take the process of collaboration between Zoe Leonard and Cheryl Dunye to bring the story of the *Watermelon Woman* to life. In the film, Dunye interviews dozens of people about a fictional African-American actress, Fae Richards—a character Dunye created partly to explore her own racial and sexual identity. At Dunye's request, Leonard carefully constructed an "authentic" historical archive for the film of eighty-two photographs documenting Richards' life using different printing processes, and different papers.

Then there's the challenging research processes that Paul Shambroom undertook in order to photograph nuclear missile stations around the country and the way workers are unperturbed by their daily interactions with tools of mass destruction or Doug Aitken's lyrical ruminations on the vast seaside diamond mines of Africa's east coast. These are very high-security locations, extremely sensitive places that required a lot of negotiating to gain access to.

LN: William Forsythe's dance solo is an accumulation and distillation of dance movement research, expressed in a very pared-down manner: a solo piece with no set, no costumes, minimal lighting, and amplified frame sound. What you see is his entire accumulation of somatic knowledge, a synopsis of his central choreographical dynamic, compressed into seven intense minutes. Similarly, Cecilia Vicuña's poetic and anthropological obsession with weaving, the most persistent of all creation myths, is filtered through her own body into sculpture, performance, and ephemeral interventions in the environment.

LP: Jason Rhoades is preoccupied with popular culture, and more specifically, with do-it-yourself handyman manuals and mail-order businesses developed around special-interest magazines and the kind of subcultures they represent in America. He amplifies the absurdity and the phantasmagorical nature of these things that are in our midst by making an "anatomical theater."

LN: It builds and builds, culminating in a huge orgasm of entertainment!

LP: I think this sense of play is very important as well as the sense of the phantasmic or the fabulous, the absurd and maybe the mad. There is a high degree of obsessiveness in the work that we've chosen.

LN: But obsessiveness that is not closed in its own loop....

LP: No, it intersects with a larger social reality.

LN: David Hammons' video performance, *Phat Free*, begins as an endless percussive sound in the darkness, then cuts to the spectral image of a self-absorbed, solitary figure kicking a bucket through his neighborhood at night— a modern, urban "death dance." In this, as in all of the other work, the social as a

medium, the individual mythology as a medium, and the narrative as a medium all intersect; the anthropological qualities of each are kept in the foreground in an effort to locate a more humanistic and unifying way of articulating the possibilities of art. Thus the emphasis on the presence of the artist's hand and the insistence on storytelling because these are the most vivid and immediate and accessible method of engaging the viewer. Storytelling is a medium that belongs to all people regardless of race, gender, or age. It abounds with common ideas, aspirations, fears, passions, transferences of narrative, and experience.

LP: But do you really think that all stories translate across those boundaries?

LN: Not all, but many do. Is it a coincidence that the erotic cosmologies of Francesco Clemente and Sue Williams, who have remarkably different origins and realities, resonate with each other? Storytelling is transmigrational—you can find the same story in many different cultures, with just slight transferences of experience and narrative within the same structure. You can find a creation myth in American Indian folklore, or in *A Thousand and One Nights*, or in *Grimm's Fairy Tales*. A story is always a model of explanation of something that happens in the world.

LP: It would seem that artists' return to narratives is a corollary to the extraordinary revival of storytelling that's been much noted in literature, law, and history for instance. There is a movement away from the objective and empirical and it has been suggested that this might represent a certain craving for protection from chaos at the end of the century. Stories are a fundamental unit of knowledge, the foundation of memory, and essential to the way we make sense of our lives. The practice of storytelling often involves identity narrative and can be used as another way to counteract that idea of the dominant American story— the middle-class, suburban-status-quo story. This is something that crops up in a lot of the work here, that investigation not only of subcultures and experiences at the margins, but of people's own personal relationships to those traditions.

LN: There can be a level of exaggeration and distortion, or reconstructed reality that comes with people telling their own story—how they embellish and change the facts, and absorb experiences that they would like to have had happen to them, or exorcise those that they wish had not happened. It's more a matter of identity poetics than identity politics. To hear a story and then take it on and retell it as if it were one's own is a very natural impulse of appropriation or transference. We see how a story can manifest itself variously as a narrative moment, as a constructed cosmology, as a model of reality, as a portrait of self-hood. Like Matthew Ritchie's cybernetic fantasy—a restless universe of painted pictures, a constantly proliferating network of visual information that holds

matter and myth, form and idea, in a dynamic state-of-play.

LP: In this context, Douglas Blau's *Sacred Allegory* reads as a kind of self-portrait and meditation on the process of creation. He has made a personal narrative out of popular images that come from a variety of sources—from books, manuals, art reproductions, film stills, glossy magazines. Or take the complex relationship to personal history played out in Shahzia Sikander's reformulated Indian miniatures, or Shashwati Talukdar's film *My Life as a Poster*, about a family trying to escape painful memories of India by coming to America.

LN: Both are narratives of violence played out against formal traditional surfaces. Sikander's delicate little traditional scenes are desecrated by strange distorted forms; Talukdar narrates a tragic story through a kind of animation theater played out across the idealized surface of an Indian movie poster.

LP: Kara Walker uses the silhouette cyclorama to express her phantasm of horrors. Imagining herself as a slave girl in the antebellum South, she confronts stereotypes about blackness through a journey into a racist, sexist, paranoid mind.

LN: The origins of all these things are contained in Wendy Ewald's ongoing project, in which she has enabled children to record their dreams and their realities by teaching them how to use a camera. What emerges about the protean, violent, humorous imagination of the child—whether it's an American child from Kentucky in the seventies or a South African child in race-torn Johannesburg or a Moroccan child in a remote village in the nineties—is that it does not differentiate between dreams and realities.

LP: It comes back to revealing the strangeness in the familiar—from Bruce Nauman bringing a new intensity to an old Appalachian tune by repetition, to Richard Phillips, who takes images from seventies fashion spreads and refilters them through a very traditional approach to painting. It's not just a nostalgic look back at something—there's a retelling and reframing of the subject.

LN: Like Ilya Kabakov's *Treatment of Memories*, in which active nostalgia is used as a cure for the pain and dullness of old age.

LP: In a ward of isolated identical hospital rooms set on either side of a corridor, the everyday memories of two parallel life histories are projected as a continuous slide show with a commentary in both Russian and English. It's a pretty open-ended scenario: on the one hand, you can see it as autobiographical; on the other, it connects with the memories of everyman.

LN: He creates a space for shared narratives that bridges the gulfs

between time, culture, and language, and in so doing, affirms the humanistic importance of storytelling.

LP: I haven't heard the term humanism used in a while with regard to artistic practice!

LN: It's one of the only means available to defend creativity against the sometimes mindless force of new technologies because it refers to the whole realm of human experience and contact. Not that I think artists reject new technologies, but they retain a certain skepticism for mechanisms that suggest that human presence might no longer be necessary. Throughout history, artists have responded to the changing conditions of society. In our times, they have been able to embody what it is to exist in a completely mediatized environment. It's not a question of whether it's more "authentic" to use a piece of clay or the Web. We always tend to talk about mediatization as a negative thing, but as you were saying earlier about the media consultant who spoke of children being born deconstructive, art suggests that mediatization is a fact of life and not necessarily a bad one.

LP: As long as the machinations are understood.

LN: And that it remains a positive contradiction and a means, not an end. Artists are very conscious of controlling their ideas and their forms and their inner environment, not leaving them to the random-select of technology or its so-called interactiveness.

LP: The technologies of popular culture that we confront in our environment every day, from electronic signs to video games, vastly supersede the computer technologies available to the individual artist. The latter seem primitive, somewhat comparable to video art in the late sixties and early seventies: the tools are relatively new and have many limitations. The introduction of video projection in the eighties and advanced digital resolution in the nineties have moved that medium into another realm—a much more sensual, sculptural, and experiential realm, as in the rich, chromatic projections of Diana Thater or the hybrid talking heads of Tony Oursler. Computer-generated art or art on the Web is not very visually satisfying at the moment. It doesn't yet allow for the attention to physical detail and the importance we've placed here on the erotics of art.

LN: With a few exceptions like Zoe Beloff and her miniature cinema of memories for the web, *Beyond*, where she uses all kinds of old or obscure films as backdrops for her self-theatricalizing forays into quick-time cybernetic

filmmaking. She likens her processes to the first encounters with celluloid in the nineteenth century, conflating hi-tech and lo-tech effects in the no-budget narratives she makes in the corner of her room. Or a painter such as Richard Prince who is using the computer to gather or generate information in the early stages of his image-making before the hand takes over.

LP: It's striking how insistent all the artists are about actually making their work, the insistence on their hand and the primary connection to materials from the simplest drawing to the most complicated installation.

LN: Yes, it comes back to what we were discussing before about economic realities and the time factor and all of the things that have prompted artists to move into a phase of more elaborate self-reflection and a strong somatic connection to a conceptual idea.

LP: In her sculptural tableau *The Four Seasons*, Jennifer Pastor has painstakingly constructed fragments from "nature": a giant moth (Spring), a corn plant (Fall), and some seashells (Summer) are engineered from artificial materials to extraordinary effect. Their mimetic quality is distorted by subtle shifts in scale and color.

LN: Or take Katy Schimert's romantic odysseys, which begin in intricate, topographical drawings and handwritten "treatments," and gradually expand into sensuous and fragile narrative fields of mesh, ceramic, tape, and thread.

LP: The most extreme form of that would be Charles Ray's elaborate preparation for his film, currently in production: learning to sew in order to make his own clothes, going to a watchmaker in Switzerland and learning how to make a watch from scratch, learning how to grind his own eyeglasses; constructing everything on his body from the ground up. Is it a way of taking control over yourself, or is it just a way of extending the use of yourself as a sculptural form?

LN: It's both existential and aggressively self-assertive. Whereas mainstream film production is dependent upon millions of different variables, hundreds of people, one-dimensional props, and clothes that are made by someone else or just tacked together for a shot, Ray is making a film of empirical truths.

LP: But then again, you won't know that, so it's the idea of reversal, of something looking normal and authentic that, in fact, has been elaborately recreated and reconstructed but invisibly so. Which is just the opposite of so many theatrical productions.

LN: He's playing on our assumptions about how films are made. He's like

Robinson Crusoe. He is compressing his life into the economy of one short film, *Self-Portrait with Homemade Clothes.*

LP: But no one will see that. It's all hidden, a secret. Whereas in Louise Bourgeois' sculptures, which incorporate her clothes saved over a lifetime, the idea of memory and the accumulations of history are all there.

LN: Except if you didn't know they were her clothes....

LP: They are still period pieces. They recall other times, other places, and the memories that are embedded in things that have been used. Ray looks like his usual self in his usual clothes, and portrays himself in a very direct way, but this is in fact the result of years of work. It is a simulation of reality, a highly constructed fiction.

LN: But it's not simulated, it's real.

LP: Except that he doesn't wear those clothes everyday.

LN: But he might.

LP: He said he wouldn't, though. They were made expressly for this one event.

LN: What is so great about all these artists is that they are really pushing the limits not only of perception but of the existential question: "What am I doing here?"

LP: Well, that may be one of the big questions for the end of the century.

LN: Especially in a world as crazy as our present one. Perhaps that was what Marcel Breuer was thinking when he designed the Whitney Museum as a fortress with a Cyclops eye looking out on the city. It's such a precise metaphor for life and art.

LP: The building is really isolated from the city in one way, but in another way it's very aggressive and very imposing, and completely unique, and hard not to notice. There it is, this eccentric building separated from the street by a moat.

LN: With an eye trained down on the chaos. And, paradoxically, what it sees is a city that is incredibly congested and chaotic, but still flowing within the controlled urban grid.

LP: Similarly, the Breuer building is very structured inside, it's very controlled. There is something tranquil about it despite the industrial nature of the materials, the hardness of the materials, the rawness of the materials. There is

an expansiveness of the space, a certain clarity that is antithetical to the street environment. It's a highly ordered environment. That is another kind of obsession.

LN: It embodies the creative tension between inside and outside, just like the artists. It's very opinionated.

LP: Sure. It knows what it is. The building didn't originally like its neighbors, it wanted to stand alone. But it has become integrated into the urban fabric despite its really having seemed an eyesore and out of place when it was first built. Now it has become a beloved landmark.

LN: It's surprising that it has resisted change in this all-consuming and dynamic city. The building is a perfect analogy of the predicament of the artist, because it is a schizophrenic one: the artist is always swinging between being an iconoclastic hermit and a social animal. Those two sides are irreconcilable.

LP: The building also stands as a metaphor for the changing dynamic between advanced art and society. It's the idea of something really strange becoming normalized—just the reverse of finding the strange in the normal.

LN: And not only that, but it's the analogy between artistic iconoclasm and how that becomes acceptable. It comes back to that idea of being constantly inside-out.

Artists' Plates

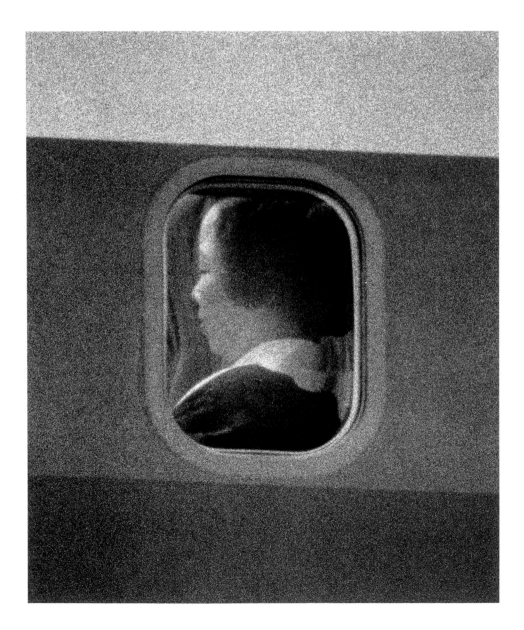

58 **John Schabel**

Untitled (Passenger #4), 1994-95
Toned gelatin silver print, edition of 10,
23 1/4 x 19 1/4 in. (59.1 x 48.9 cm)

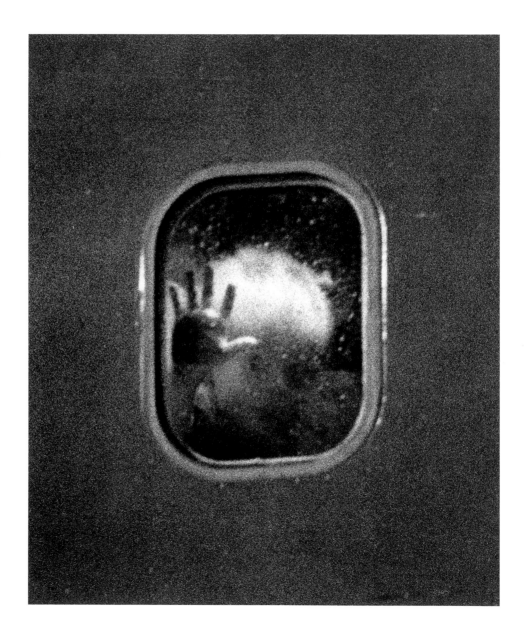

Untitled (Passenger #3), 1994-95
Toned gelatin silver print, edition of 10,
23 1/4 x 19 1/4 in. (59.1 x 48.9 cm)

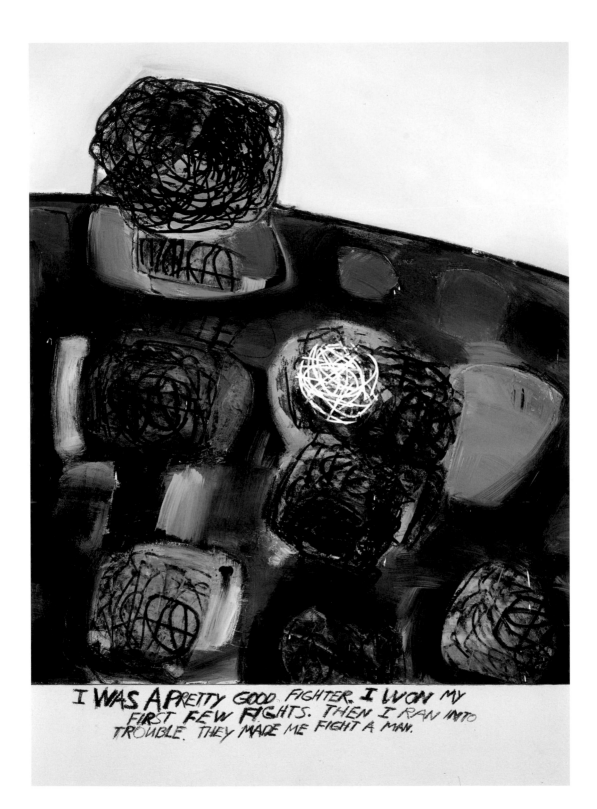

Richard Prince

Pretty Good, 1996
Acrylic, silkscreen, and charcoal on canvas,
65 x 48 in. (165 x 121.9 cm)

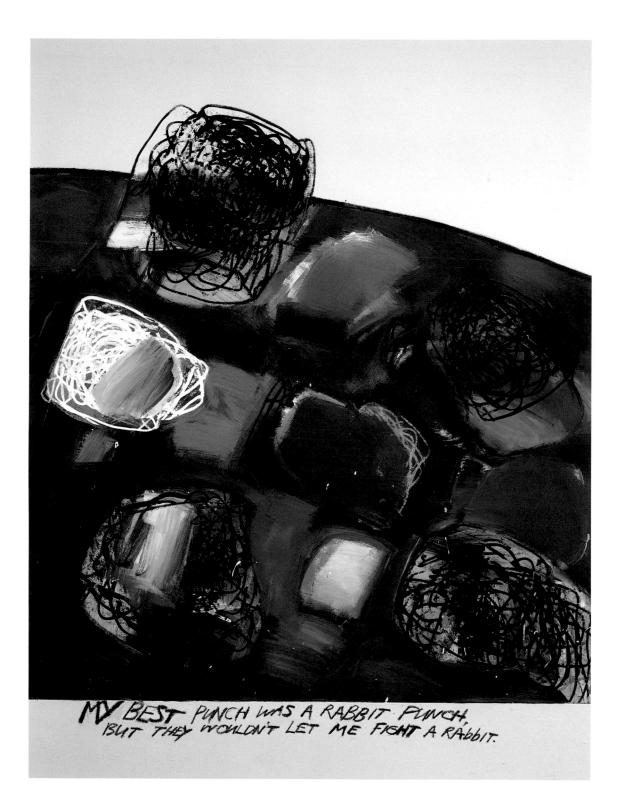

My Best, 1996
Acrylic, silkscreen, and oil stick on canvas,
63 x 48 in. (160 x 121.9 cm)

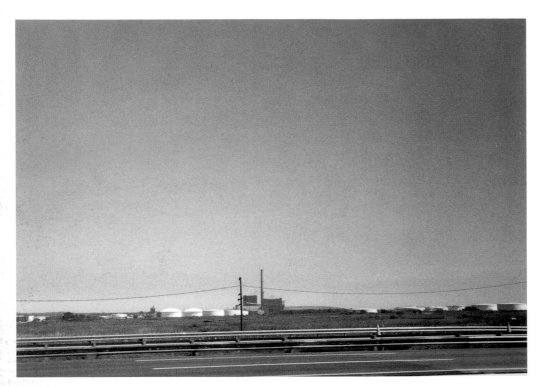

Photograph by Michael Ashkin, 1996

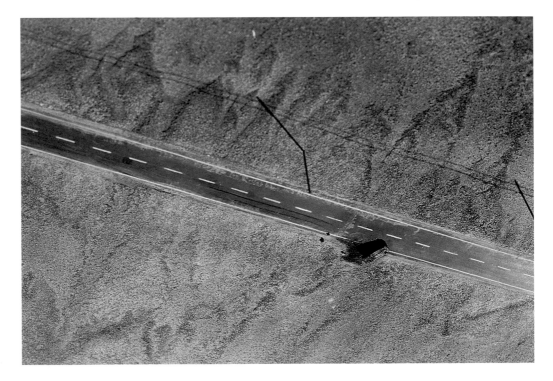

62 **Michael Ashkin**

No. 27, 1996 (detail)
Flour, portland cement, and N-scale models,
3 x 96 x 240 in. (7.6 x 243.8 x 609.6 cm)

No. 33, 1996 (detail)
EnviroTex Lite, wood, dirt, glue, and N-scale models,
34 x 48 x 252 in. (86.4 x 121.9 x 640.1 cm)

Vija Celmins

Night Sky #9, 1994-96
Oil on canvas, 38 x 47 in. (96.5 x 119.4 cm)

Night Sky #7, 1994-96
Oil on canvas, 38 x 47 in. (96.5 x 119.4 cm)
Collection of Aaron Fleischman

Aaron Rose

Untitled (The Untergrowth Series), 1994-96
Unique photo, 11 x 14 in. (27.9 x 35.6 cm)

Untitled (The Untergrowth Series), 1994-96
Unique photo, 11 x 14 in. (27.9 x 35.6 cm)

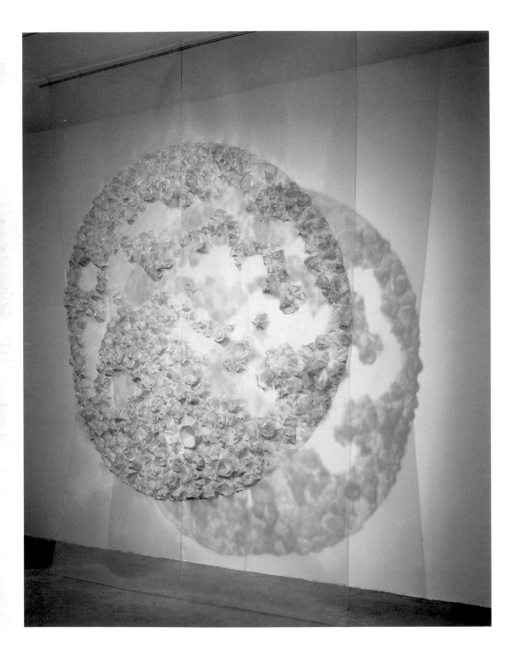

Katy Schimert The Moon, 1995
Aluminum screen, 144 x 96 x 6 in.
(365.8 x 243.8 x 15.2 cm)
Collection of Susan and Michael Hort

Untitled, 1996, installation at "Wanås 96,"
Wanås Sculpture Park, Knislinge, Sweden
Cast bronze with chrome and lacquer, dimensions vary

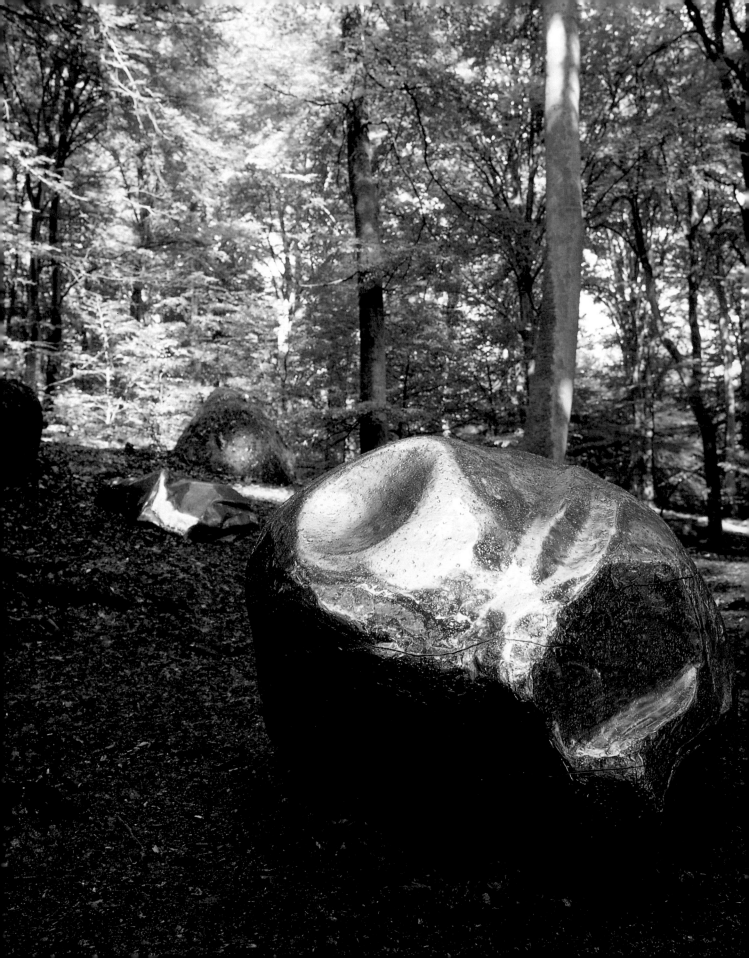

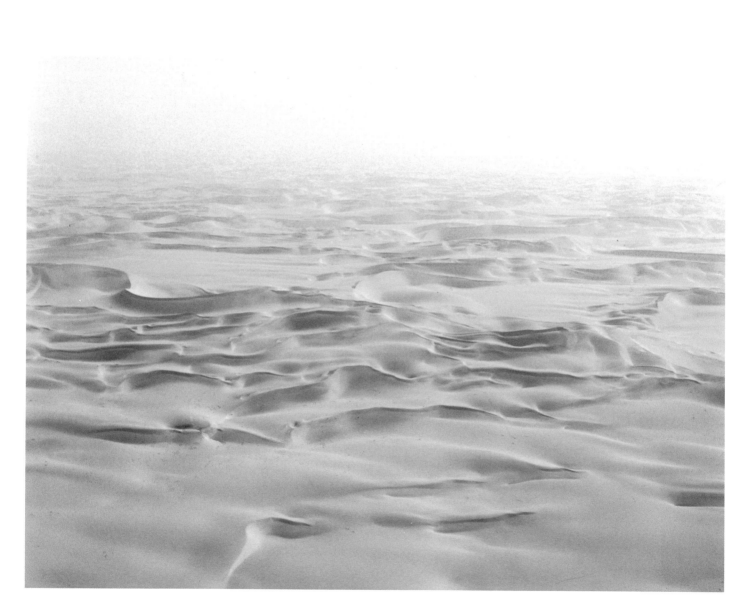

Still from **Diamond Sea**, 1997
Videotape, color, sound; 19 minutes

Doug Aitken 71

72 **Gabriel Orozco**

Common Dream, 1996
Cibachrome, edition of 5, 12 7/16 x 18 5/8 in. (31.6 x 47.3 cm)

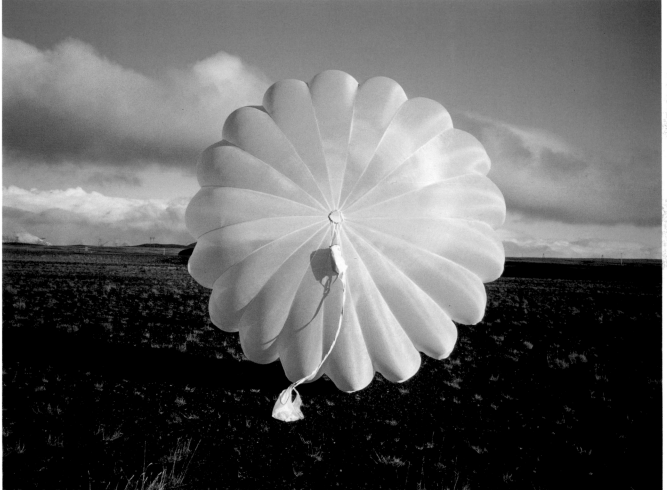

Parachute in Iceland, 1996

Cibachrome, edition of 5, 12 7/16 x 18 5/8 in. (31.6 x 47.3 cm)

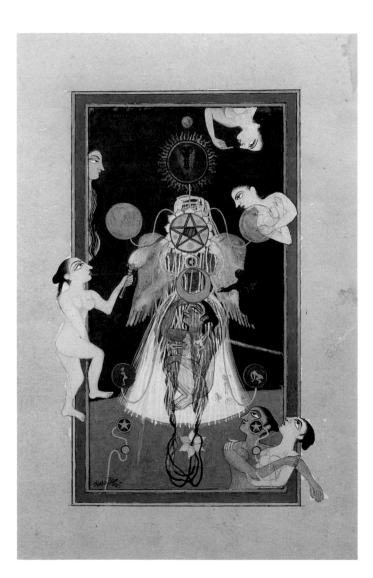

Shahzia Sikander

Apparatus of Power, 1995
Vegetable pigment, dry pigment, watercolor, and tea water
on wasli handmade paper, 9 x 6 in. (22.9 x 15.2 cm)
Collection of Carol S. Craford

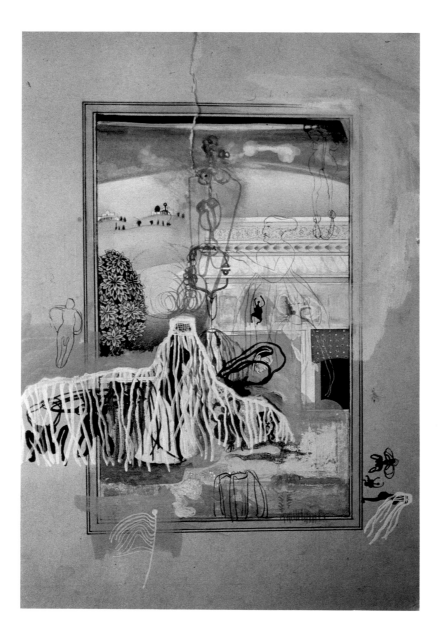

Whose Veiled Anyway, 1995
Vegetable pigment, dry pigment, watercolor, and tea water
on wasli handmade paper, 11 x 14 in. (27.9 x 35.6 cm)

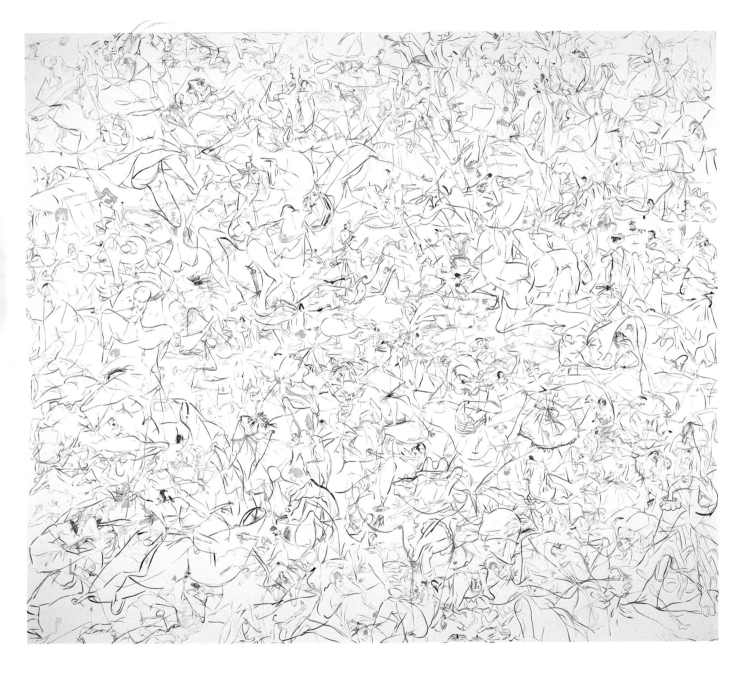

Sue Williams

Large Blue and Orange, 1996
Oil and acrylic on canvas, 96 x 108 in. (243.8 x 274.3 cm)

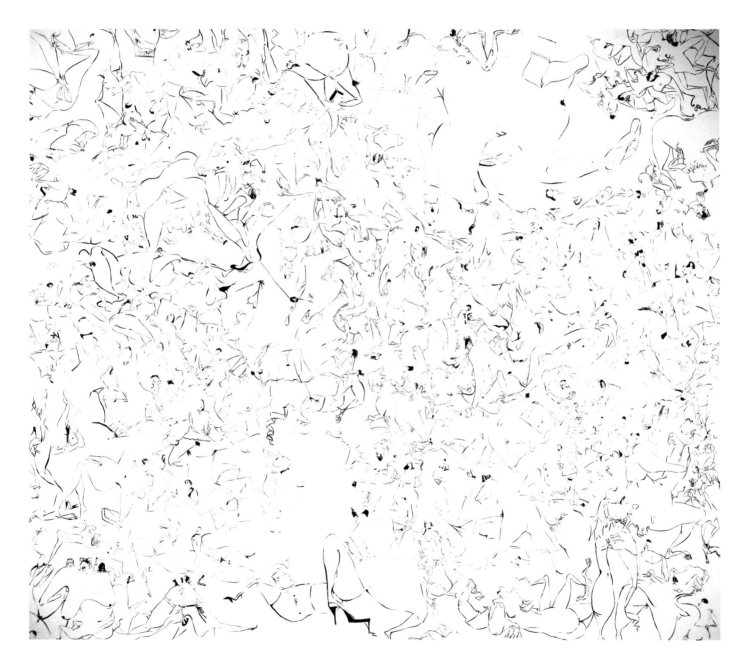

Large and Itchy, 1996
Oil and acrylic on canvas, 96 x 108 in. (243.8 x 274.3 cm)

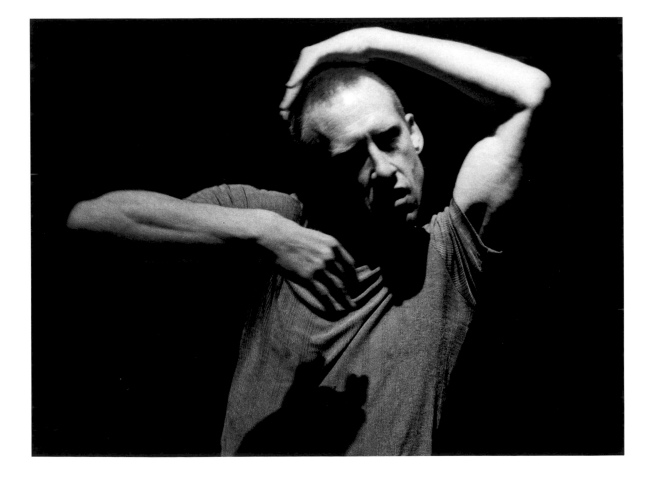

William Forsythe

Stills from **Solo**, 1995
Videotape, black-and-white, sound; 7 minutes

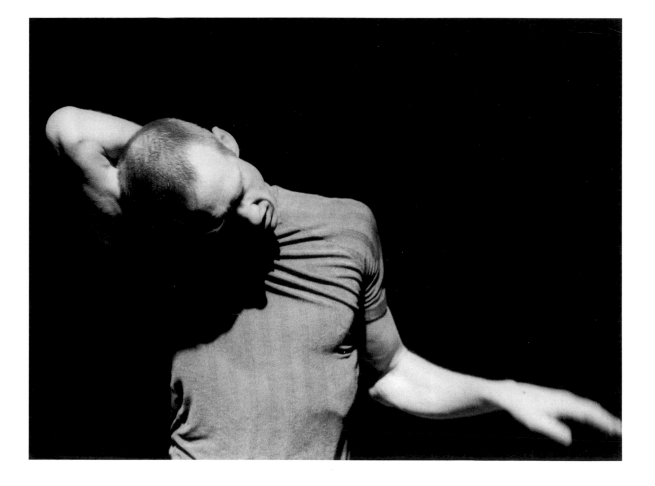

Francesco Clemente

Semana Santa VII, 1994-95
Pastel on paper, 26 x 19 in. (66 x 48.3 cm)

Musica da Camera, 1994-95
Pastel on paper, 26 x 19 in. (66 x 48.3 cm)

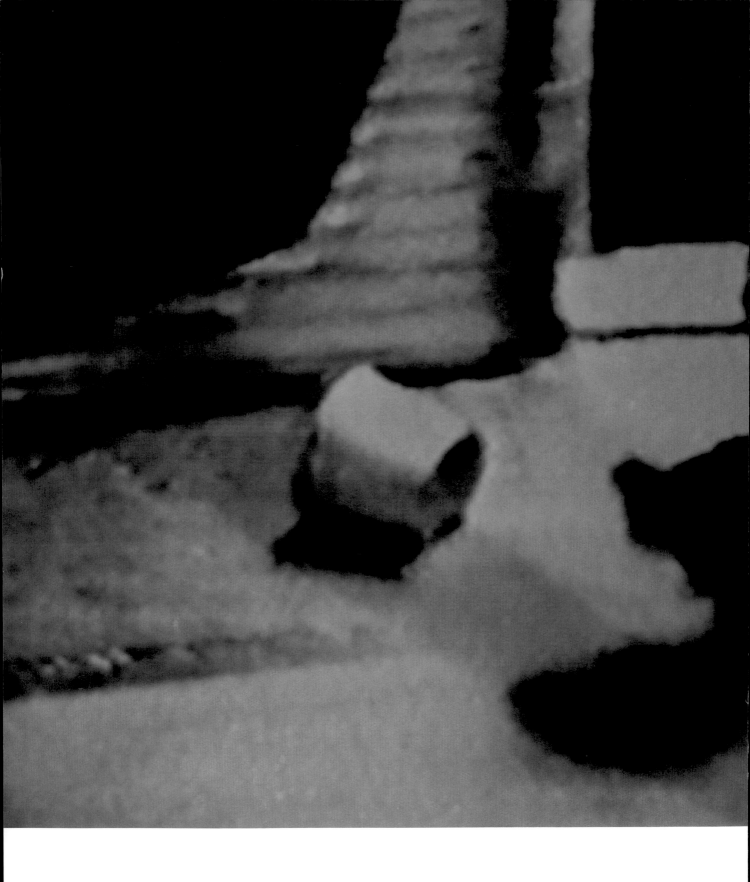

82 **David Hammons**

Still from **Phat Free**, 1995-97
Videotape, color, sound; 7 minutes

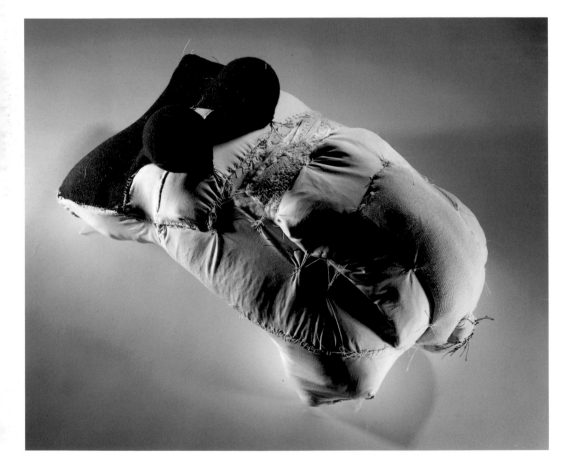

84 **Louise Bourgeois** Untitled, 1996 Cell (Clothes), 1996
Fabric, 10 x 20 1/2 x 11 1/2 in. Wood, glass, fabric, rubber, and mixed media,
(25.4 x 52.1 x 29.2 cm) 83 x 174 x 144 in. (210.8 x 442 x 365.8 cm)

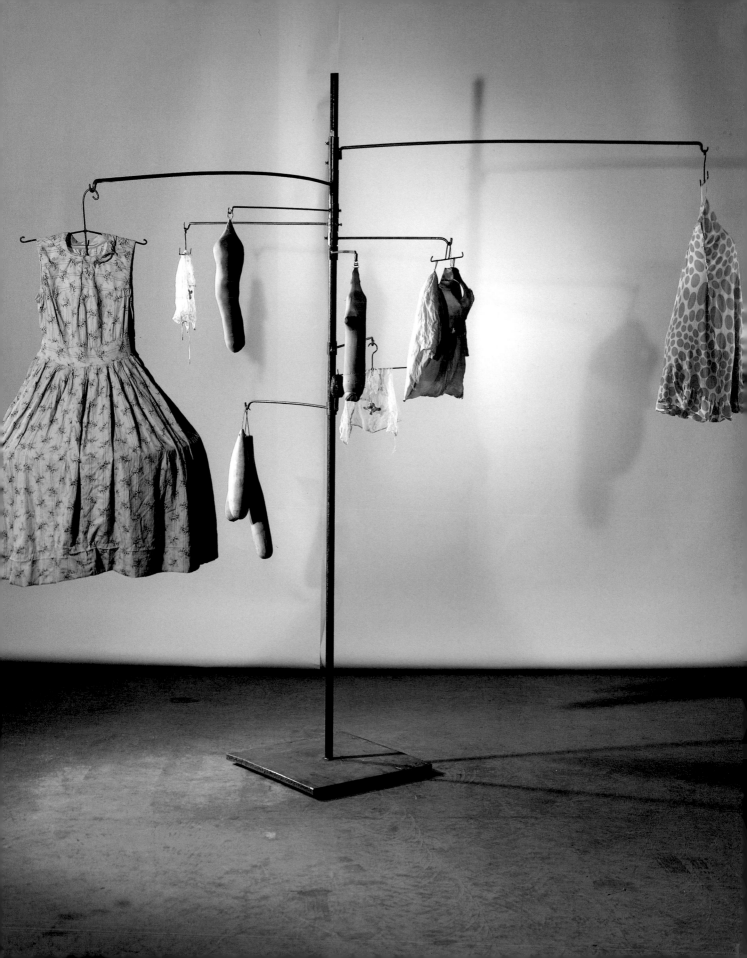

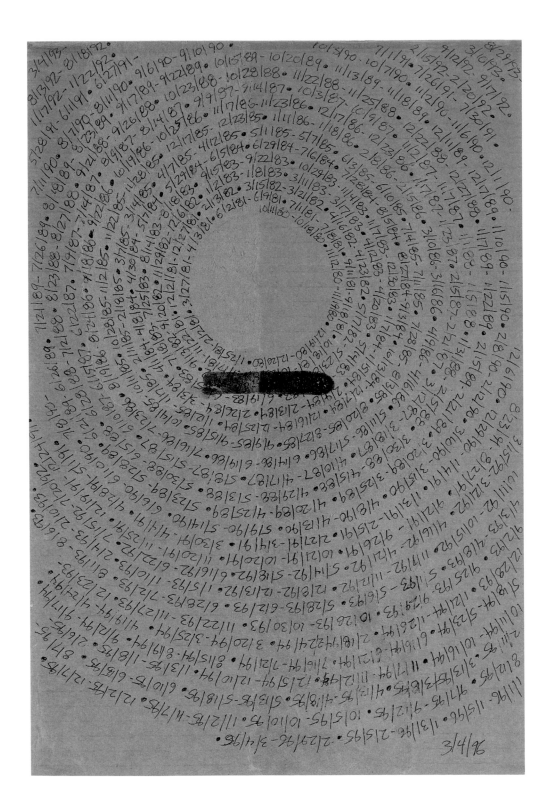

86 **Annette Lawrence**

Five, 3/96, from **Moons,** 1996
Mixed media on paper, 15 x 10 in. (38.1 x 25.4 cm)

Seven, 5/96, from Moons, 1996
Mixed media on paper, 15 x 10 in. (38.1 x 25.4 cm)

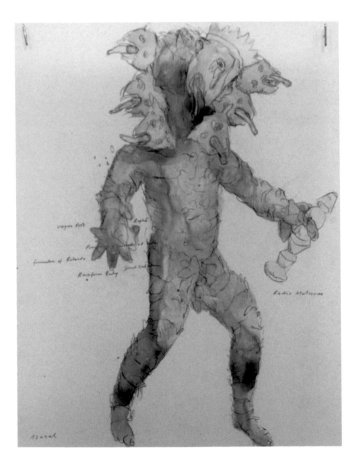

88 **Matthew Ritchie** Azazel, 1995
Ink and graphite on mylar,
11 x 8 1/2 in. (27.9 x 21.6 cm)

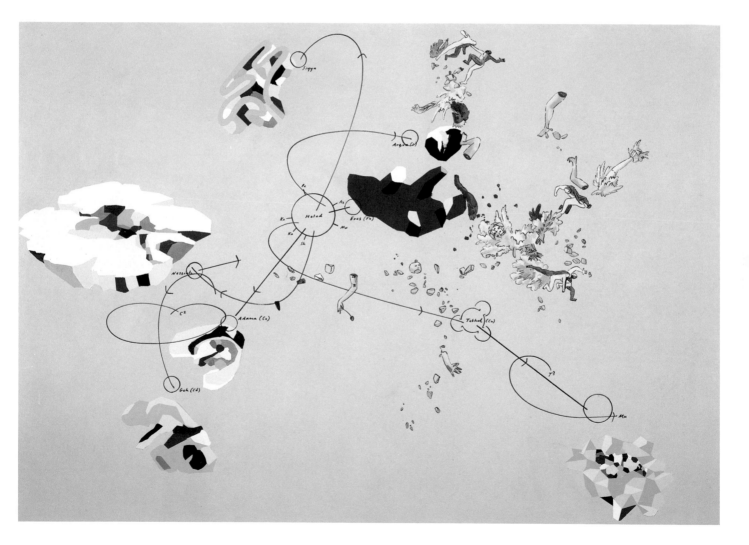

Seven Earths, 1995
Oil and marker on canvas, 60 x 84 in. (152.4 x 213.4 cm)

Cecilia Vicuña Street Weaving, New York, 1993

Hilumbres-Allqa, installation at the Béguinage, Kortrijk, Belgium, 1994
Cotton thread, dimensions vary

Uno Momento/the theatre in my dick/ a look to the physical/ephemeral, 1996
Mixed media, approximately 300 x 840 in. (762 x 2133.6 cm)
Hauser & Wirth, Zurich

Jason Rhoades

Pizza City, 1991-96 (details)
Mixed media, approximately 300 x 600 in. (762 x 1524 cm)
MAK-Österreichisches Museum für Angewandte Kunst, Vienna

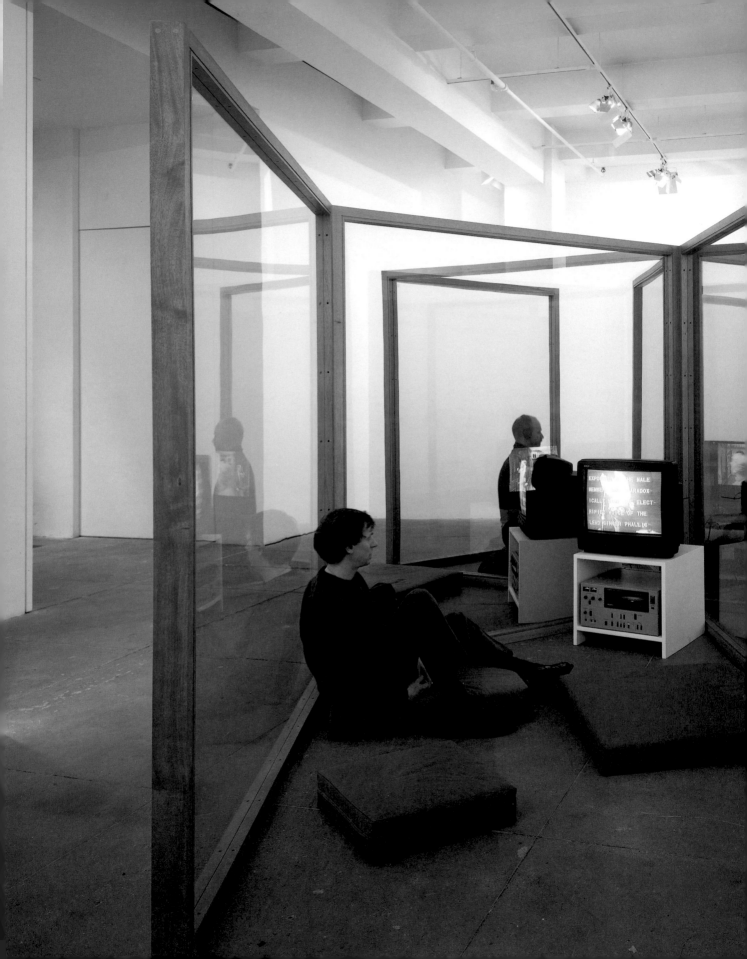

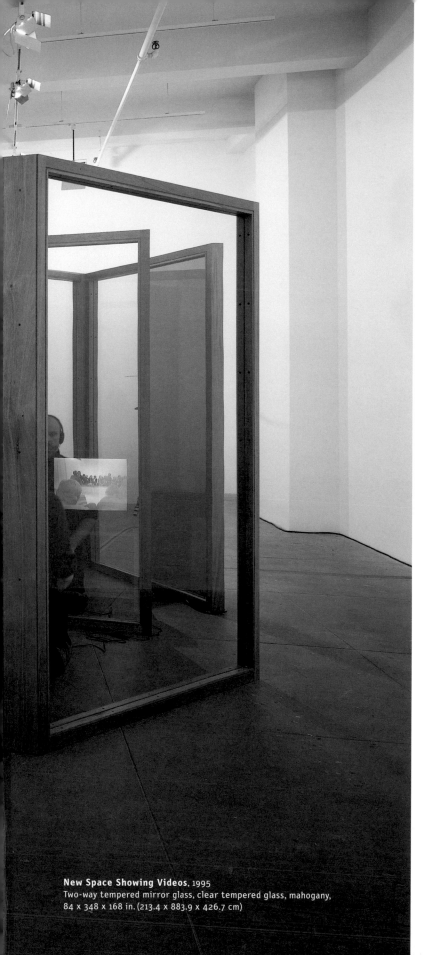

New Space Showing Videos, 1995
Two-way tempered mirror glass, clear tempered glass, mahogany,
84 x 348 x 168 in. (213.4 x 883.9 x 426.7 cm)

N.Y.O. & B., 1996, installation at the New York Kunsthalle
Wood, steel, sheetrock, paint, linoleum tile, fittings,
and fixtures, 336 x 600 x 240 in. (853.4 x 1524 x 609.6 cm)

Glen Seator

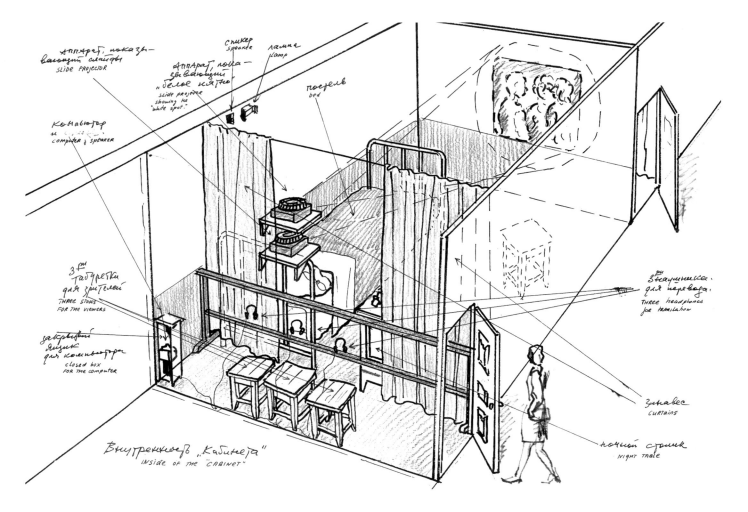

Аппарат, показы-
вающт слайды
SLIDE PROJECTOR

Спикер
speaker

лампа
lamp

Аппарат, пока-
зывающий
"белое пятно"
slide projector
showing the
"white spot"

постель
bed

Компьютер
и спикер
computer & speaker

3-ри
Табуретки
для зрителей
THREE STOOLS
FOR THE VIEWERS

закрытый
ящик
для компьютера
CLOSED BOX
FOR THE COMPUTER

3-ри
наушники
для перевода
THREE headphones
for translation

зaнавec
CURTAINS

ночный столик
NIGHT TABLE

Внутренность "Кабинета"
INSIDE OF THE "CABINET"

Treatment with Memories, 1997
A proposal for the 1997 Biennial

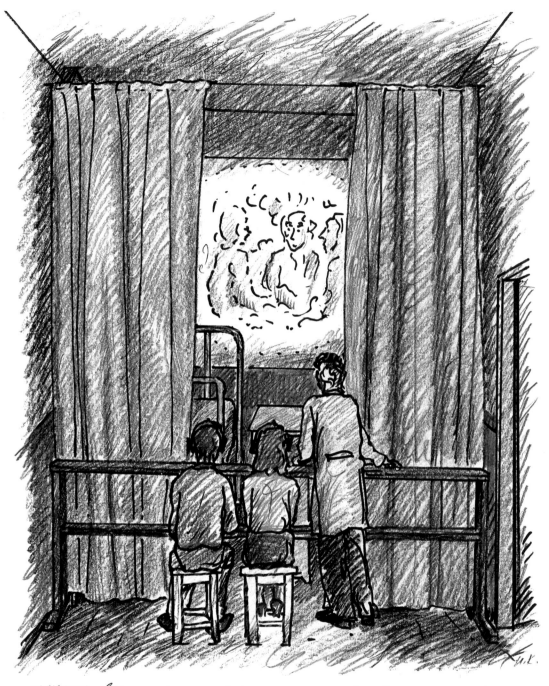

„ЛЕЧЕНИЕ воспоминаниями" Уитни Бьеннале 1997. Эскиз инсталляции.

Внутренность кабинета

"TREATMENT WITH MEMORIES." WHITNEY BIENNIAL. 1997. SKETCH OF THE INSTALLATION
INSIDE OF THE CABINET.

Martin Kersels

Objects of the Dealer, 1995,
installation at the Dan Bernier Gallery, Santa Monica, California
Desk, computer, fax, refrigerator, phone, drill, tape measure, tape dispenser,
Rolodex, Filofax, rubber stamp, tape players, speakers, and aluminum switches

104 **Lari Pittman**

Once Awkward, Now Spacious and Elastic, 1996
Oil on prepared wood with attached framed work on paper, 60 x 48 in. (152.4 x 121.9 cm)
Collection of Mr. and Mrs. Milton Fine

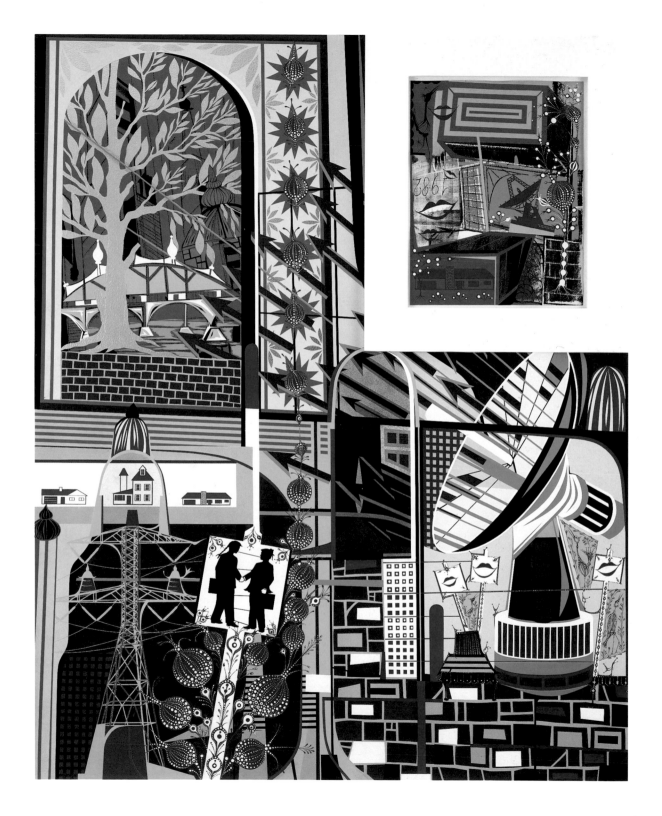

Once Inverted, Now Throw-Away and Exponential, 1996
Oil on prepared wood with attached framed work on paper,
60 x 48 in. (152.4 x 121.9 cm)
Private Collection

Bureau of Inverse Technology

Still from **Suicide Box**, 1996
Videotape, color, sound; 13 minutes

Philip-Lorca diCorcia

New York, 1993, from the series **Streetwork**, 1993-
Ektachrome, edition of 15, 30 x 40 in. (76.2 x 101.6 cm)

London, 1995, from the series **Streetwork**, 1993-
Fktachrome, edition of 15, 30 x 40 in. (76.2 x 101.6 cm)

Robert Attanasio

Still from **Not from Concentrate**, 1995
Videotape, color, sound; 6 minutes

Still from **Cable Xcess**, 1996
Videotape, color, sound; 4 minutes, 48 seconds

Kristin Lucas 111

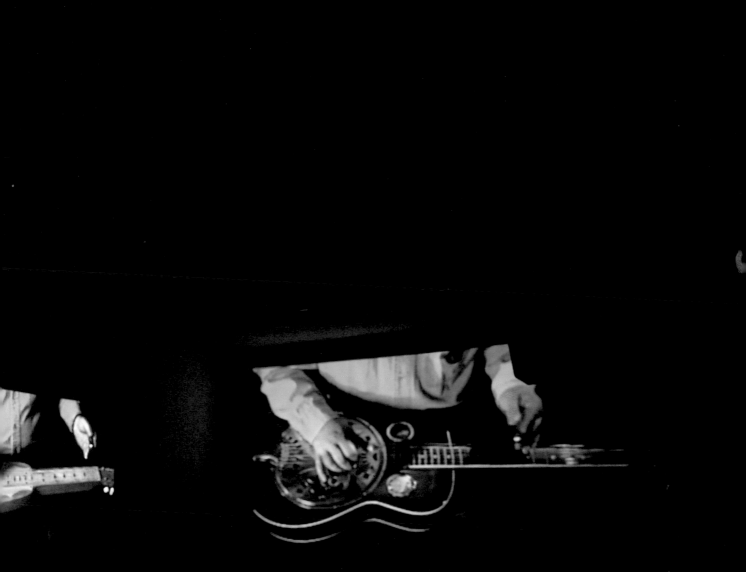

End of the World, 1996, with Lloyd Maines
Video projectors and laserdiscs
Private collection

Bruce Nauman

Rajae Jabine, "My little sister, Hafsa," Morocco, 1995
from the series **Dreams**, 1978-
Gelatin silver print, 16 x 20 in. (40.6 x 50.8 cm)

Johnny Wilder, Kentucky, 1981, from the series **Dreams**, 1978-
Gelatin silver print, 16 x 20 in. (40.6 x 50.8 cm)

Denise Dixon, "Phillip and Jamie are creatures
from outerspace in their space ship," Kentucky, 1979
from the series Dreams, 1978-
Gelatin silver print, 11 x 14 in. (27.9 x 35.6 cm)

Wendy Ewald 115

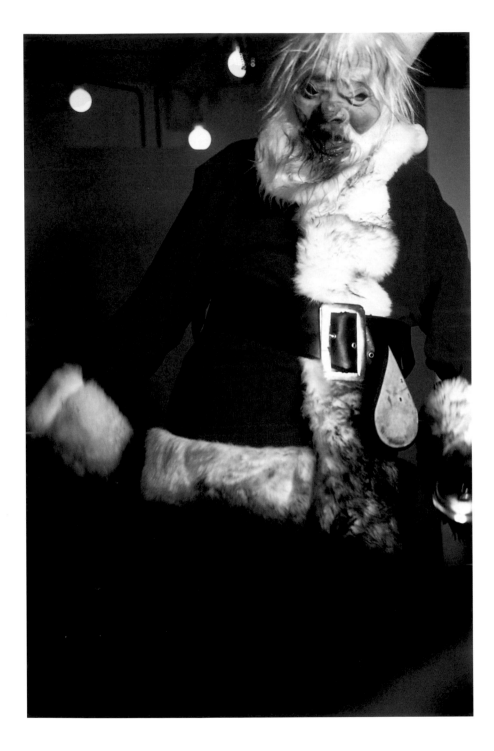

116 **Paul McCarthy**

Santa Claus, 1996
Photographs from performance at the Tomio Koyama
Gallery, Tokyo

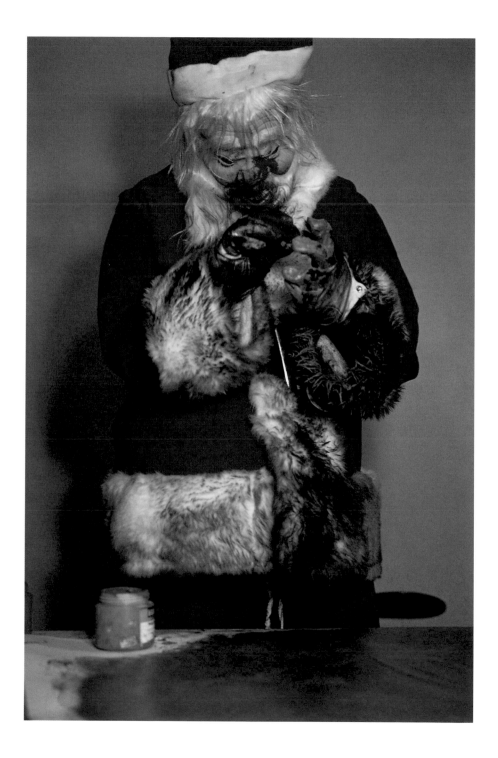

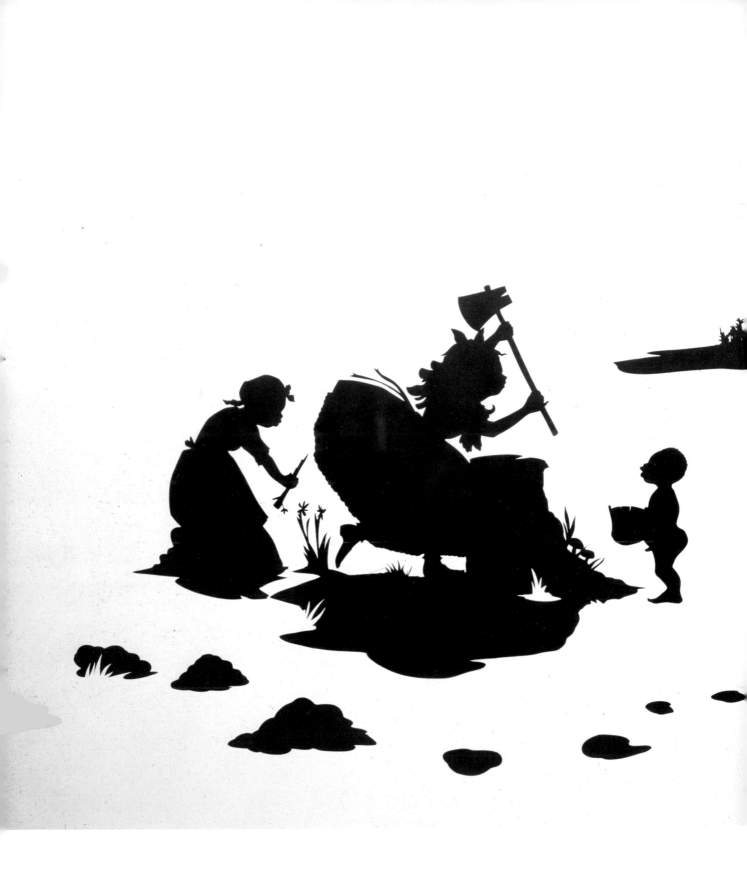

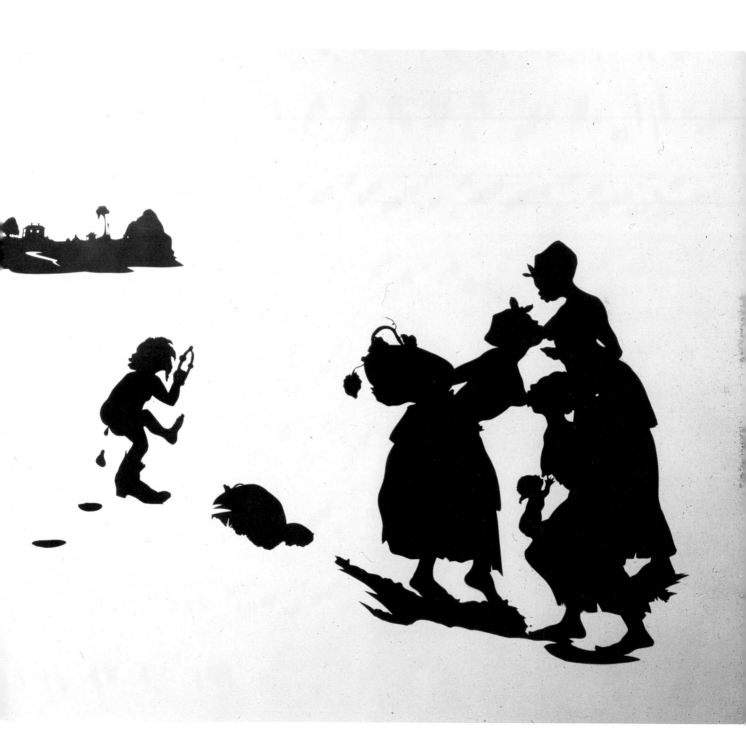

The End of Uncle Tom and the Grand Allegorical
Tableau of Eva in Heaven, 1995
Cut paper and adhesive on wall, dimensions vary
Collection of Jeffrey Deitch

Kara Walker 119

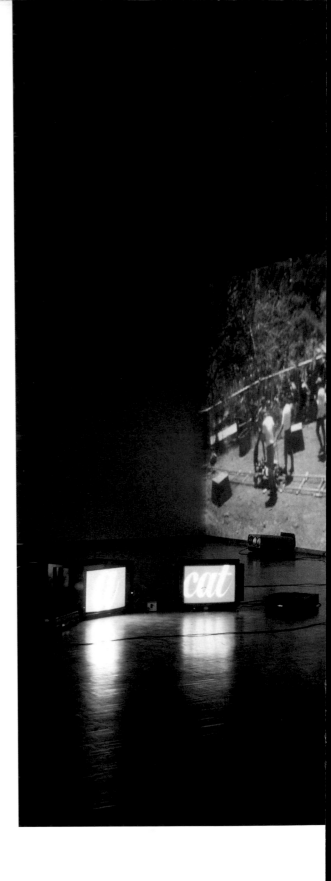

Still from **Electric Mind**, 1996

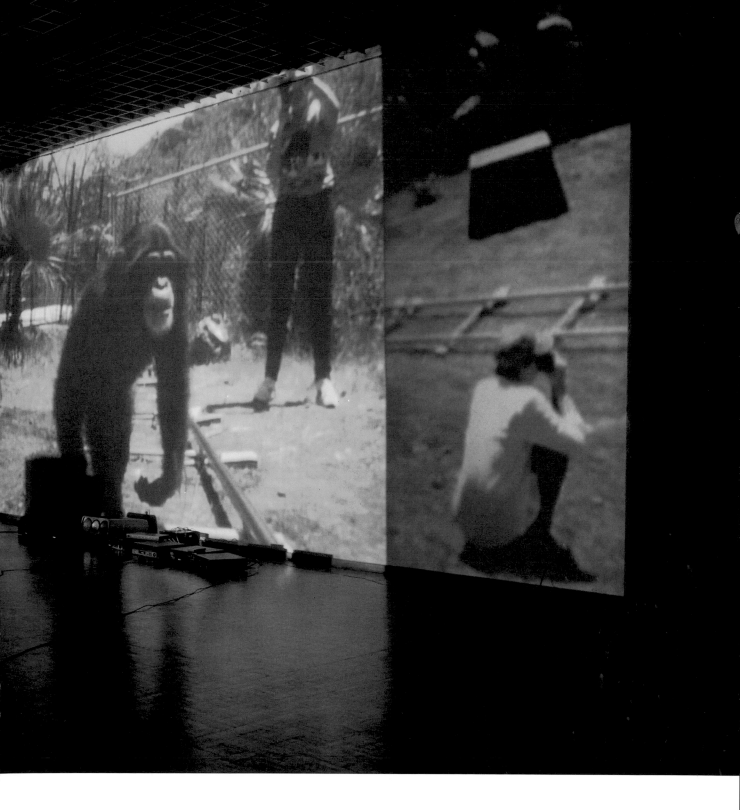

Electric Mind, 1996 (detail)
Videotape, video projectors, video monitors, laserdisc players,
sync generator, and laserdiscs, dimensions vary

Still from **Tuning the Sleeping Machine**, 1996
16mm film, color, sound; 13 minutes

David Sherman 123

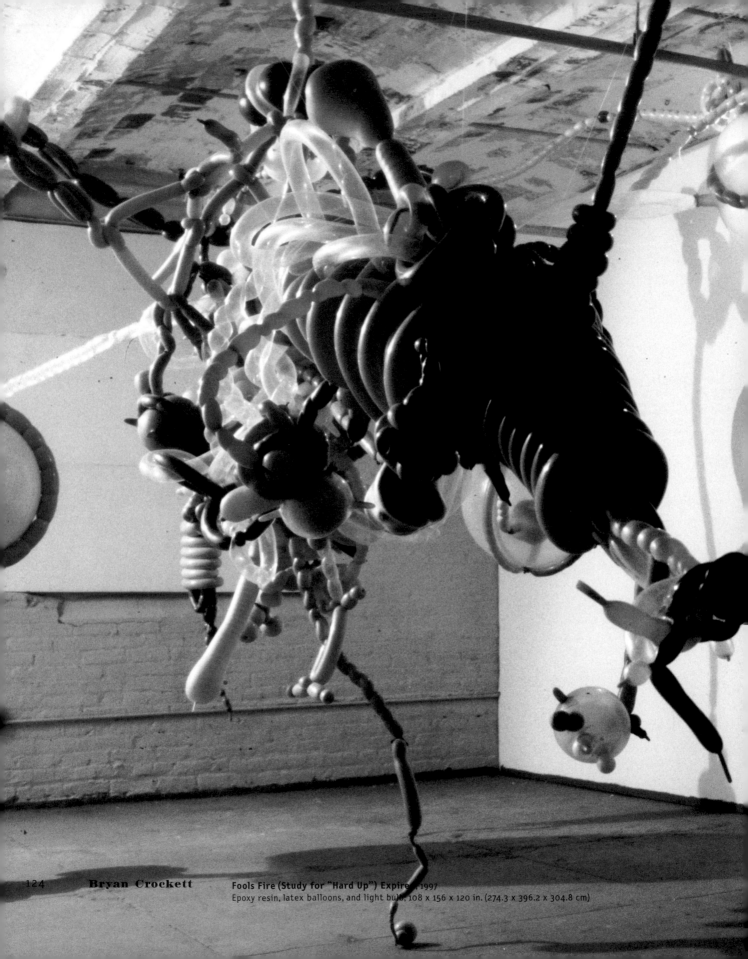

Bryan Crockett **Fools Fire (Study for "Hard Up") Expired,** 1997
Epoxy resin, latex balloons, and light bulb, 108 x 156 x 120 in. (274.3 x 396.2 x 304.8 cm)

126 **Michael Gitlin**

Still from **Berenice**, 1996
16mm film with optical soundtrack, color, sound; 51 minutes

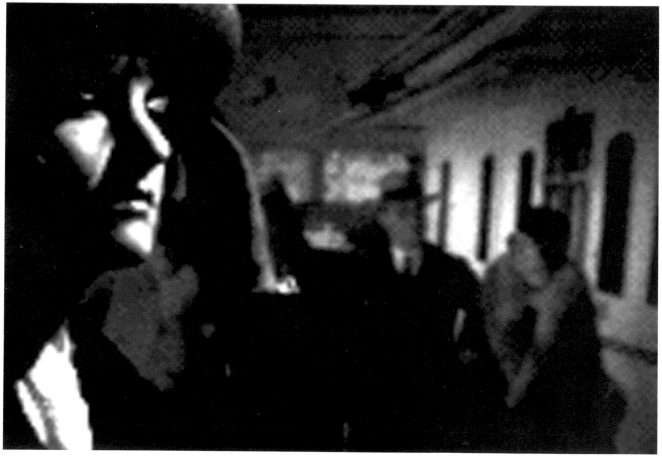

Still from **Beyond**, 1997
CD-ROM

Zoe Beloff

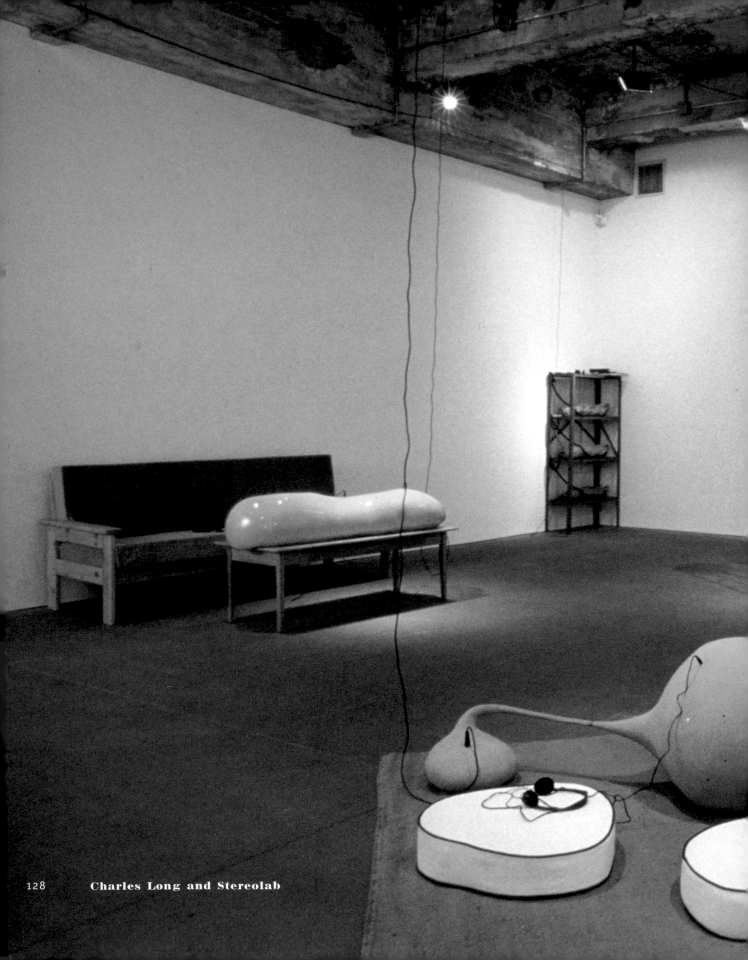

Charles Long and Stereolab

The Amorphous Body Study Center, 1995,
installation at the Tanya Bonakdar Gallery, New York
Mixed media, dimensions vary

AS THE YEARS ADD
TO THE DISTANCE.

Raymond Pettibon

No Title, 1996
Pen and ink on paper
19 3/4 x 14 in. (50.2 x 35.6 cm)

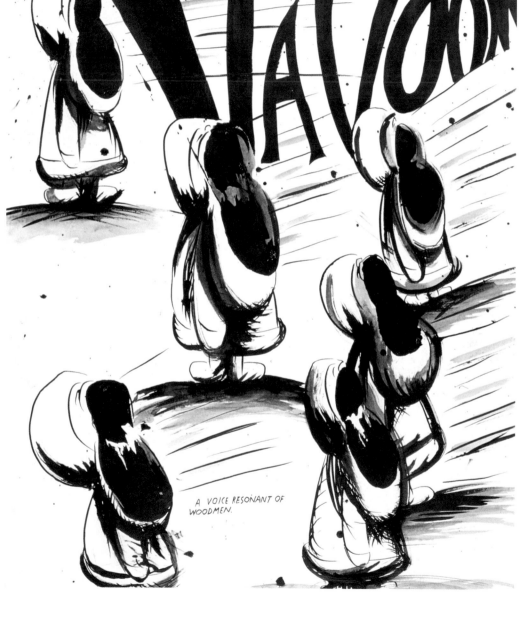

No Title, 1996
Pen and ink on paper
29 3/4 in. x 22 in. (75.6 x 55.9 cm)

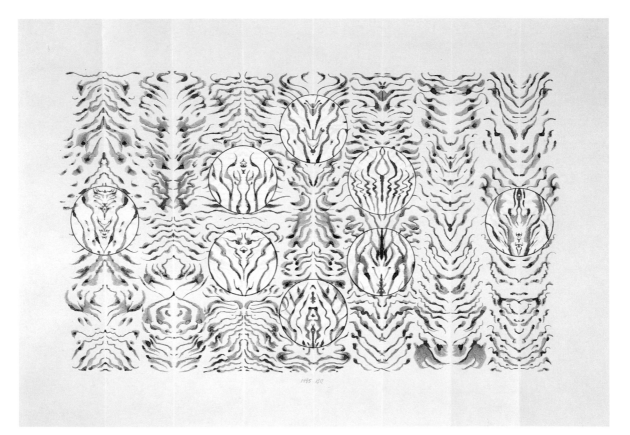

Bruce Conner

TYGER! TYGER!, June 30, 1995
Ink and graphite on paper, 14 7/8 x 21 3/4 in. (37.8 x 55.2 cm)

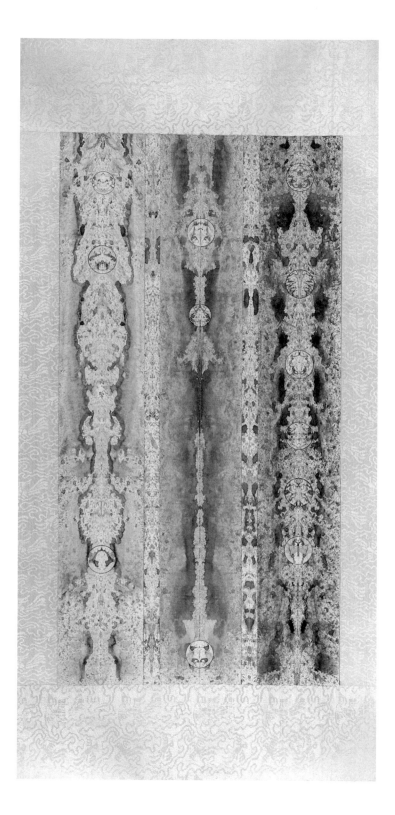

UNTITLED, June 15, 1996
Ink on paper, YES glue, and silk, 35 7/8 x 17 1/2 in. (91.1 x 44.5 cm)

Still from **The Georgetown Loop**, 1995
35mm film, black-and-white, silent; 10 minutes **Ken Jacobs** 135

Sam Easterson

Still from **Blowout**, 1995
Videotape, color, sound; 3 minutes, 25 seconds

Still from **the birds**, 1995
Videotape, color, sound; 2 minutes, 58 seconds

Inka binka bottle of ink
Cork fell off and you stink
Not because you're dirty
Not because you're clean
But because you kissed a boy
Behind a dirty magazine.....

Rudie toot-toot rudie toot-toot
We are the boys from the Institute
We don't drink or smoke or chew
And we don't go out with girls that do.....

Joy to the world
The teacher's dead
We barbequed her head
What happened to her body?
We flushed it down the potty
And around and around and around it went
And around and around and around it went
And around and around and around it went
Joy to the world
The school burned down
And the teachers are all dead
If you are looking for the principal
He's hanging from the flag
With a rope around his neck
With a rope around his neck
With a rope around his neck.....

Mansheshe, 1997
Ceramic, glass, video player, videocassette,
CPJ 200 video projector, sound,
approximately 11 x 7 x 8 in. (27.9 x 17.8 x 20.3 cm) each

Tony Oursler

Still from Wrong Guys, 1997
Videotape and 35mm film, color
and black-and-white, sound; 42 minutes

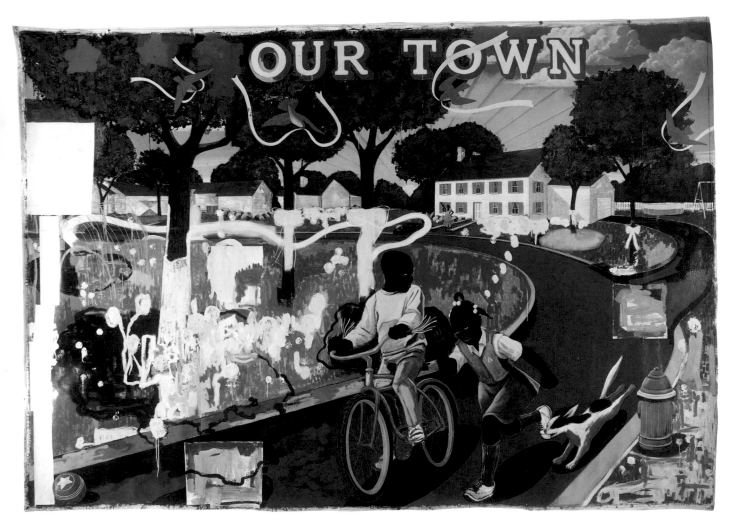

142 **Kerry James Marshall**

Our Town, 1995
Acrylic and collage on canvas, 100 x 144 in. (254 x 365.8 cm)

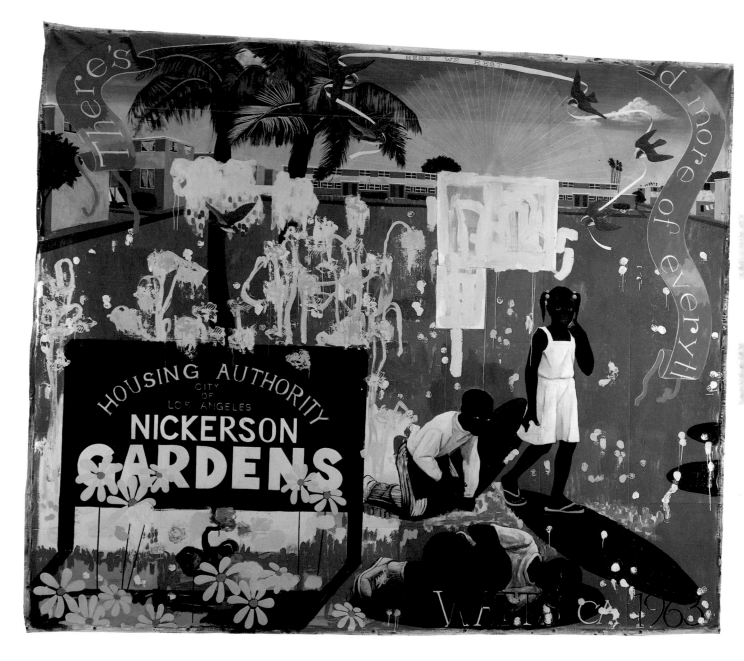

Watts 1963, 1995
Acrylic and collage on canvas, 114 x 135 in. (290 x 343 cm)
The Saint Louis Art Museum, Missouri

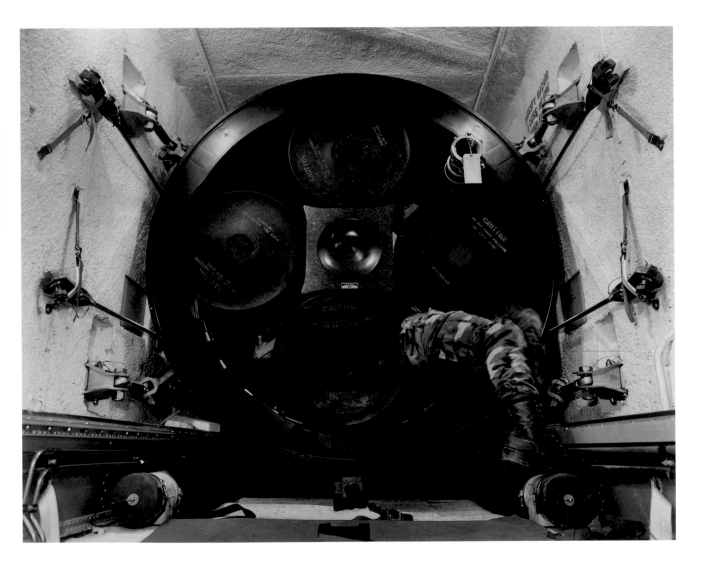

144 **Paul Shambroom**

Untitled (Minuteman II missile in truck, technician
preparing for transport in Transporter Erector vehicle,
Ellsworth Air Force Base, South Dakota), 1992,
from the series **Nuclear Weapons**, 1990-95
Color coupler print, 48 x 60 in. (121.9 x 152.4 cm)
Walker Art Center, Minneapolis

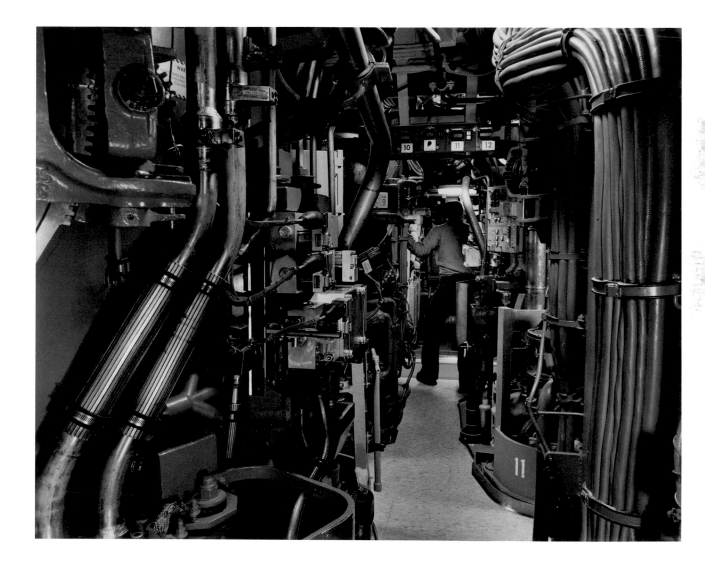

Untitled (Trident submarine missile tubes, 2nd level,
USS Alaska, Naval Submarine Base Bangor, Washington), 1992,
from the series **Nuclear Weapons**, 1990-95
Color coupler print, 48 x 60 in. (121.9 x 152.4 cm)

146 **Christopher Münch**

Still from Color of a Brisk and Leaping Day, 1996
35mm film, black-and-white, sound; 87 minutes

BRAVE
MEN

RUN

IN

MY

FAMILY

Brave Man's Porch, 1996
Acrylic on canvas, 82 x 50 in. (208.3 x 127 cm)
Collection of Anthony D'Offay

Edward Ruscha 147

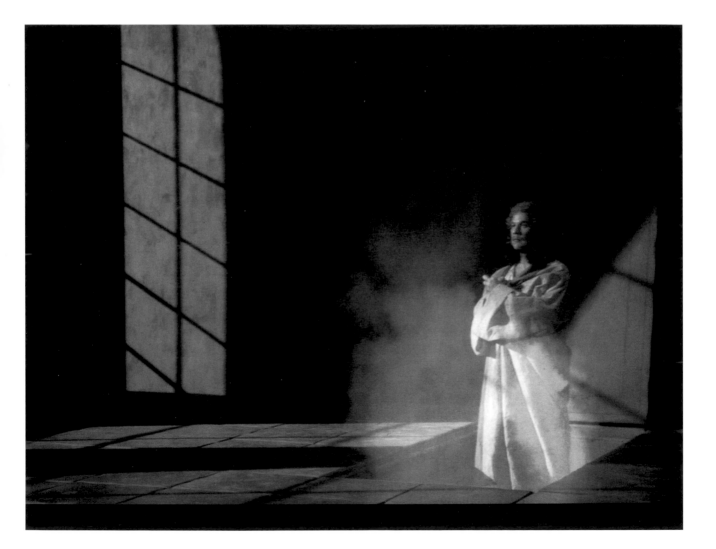

148 **Robert Wilson**

Still from **La Mort de Molière**, 1995
Videotape, color, sound; 47 minutes

Still from **The Escape (of Marie Antoinette)**, 1996
16mm film, color, sound; 12 minutes

T.J. Wilcox 149

Zoe Leonard **The Fae Richards Photo Archive**, 1993-96
Created for Cheryl Dunye's film **Watermelon
Woman**, 1996
82 photographs of varying dimensions and types,
edition of three

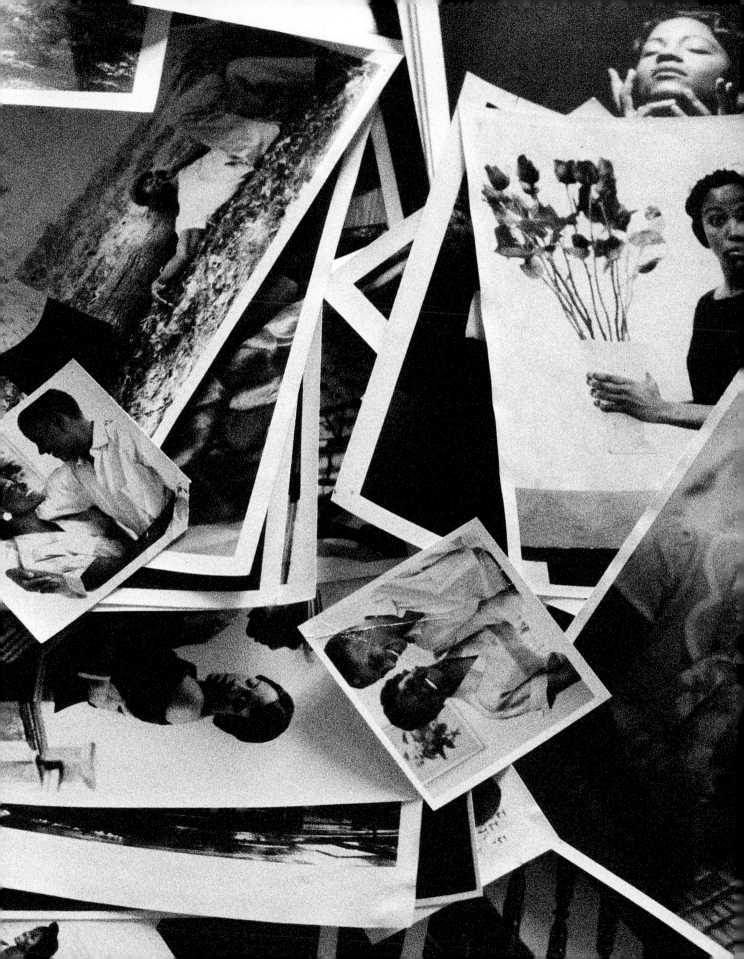

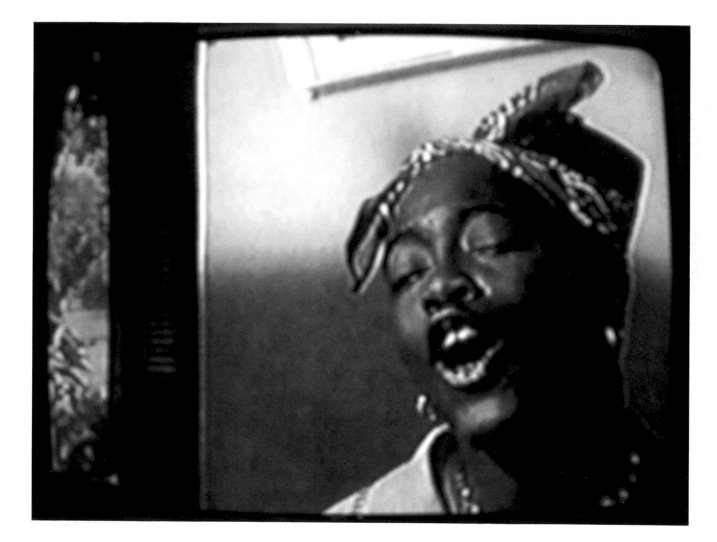

Still from **Watermelon Woman**, 1996
35mm film, black-and-white and color, sound; 90 minutes

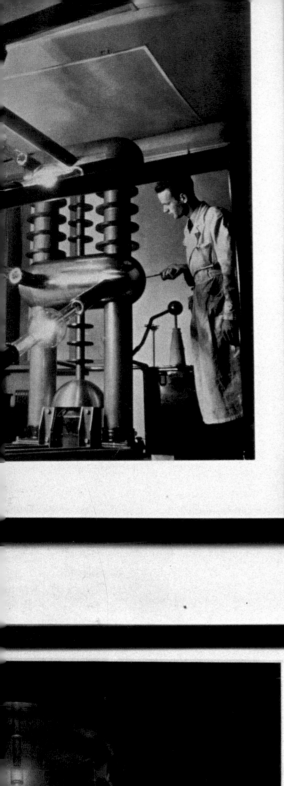
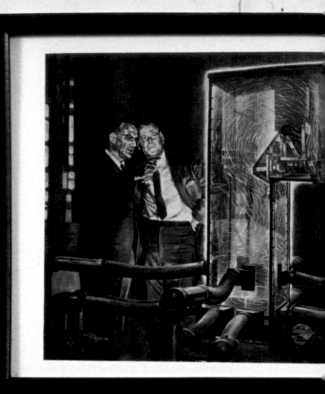

Douglas Blau

Sacred Allegory, 1996 (working detail)
Mixed-media assemblage, 36 x 216 in. (91.4 x 548.6 cm) overall

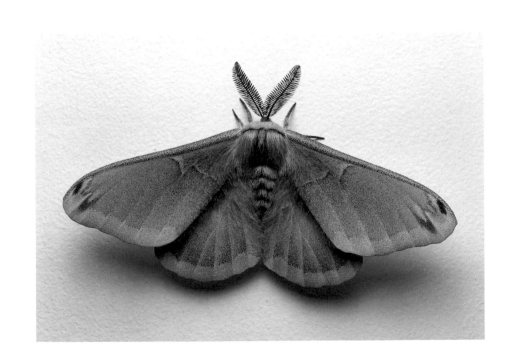

156 **Jennifer Pastor**

The Four Seasons: Untitled (Spring), 1994-96
High-density polyurethane foam, brass, hair, and paint,
approximately 3 x 6 x 1 1/2 in. (7.6 x 15.2 x 3.8 cm)
Collection of Peter and Eileen Norton

The Four Seasons: Untitled (Fall), 1994-96 (detail),
Copper, plastic, polyurethane paint, and oil paint,
20 x 78 x 57 in. (304.8 x 198.1 x 144.8 cm)
Collection of Peter and Eileen Norton

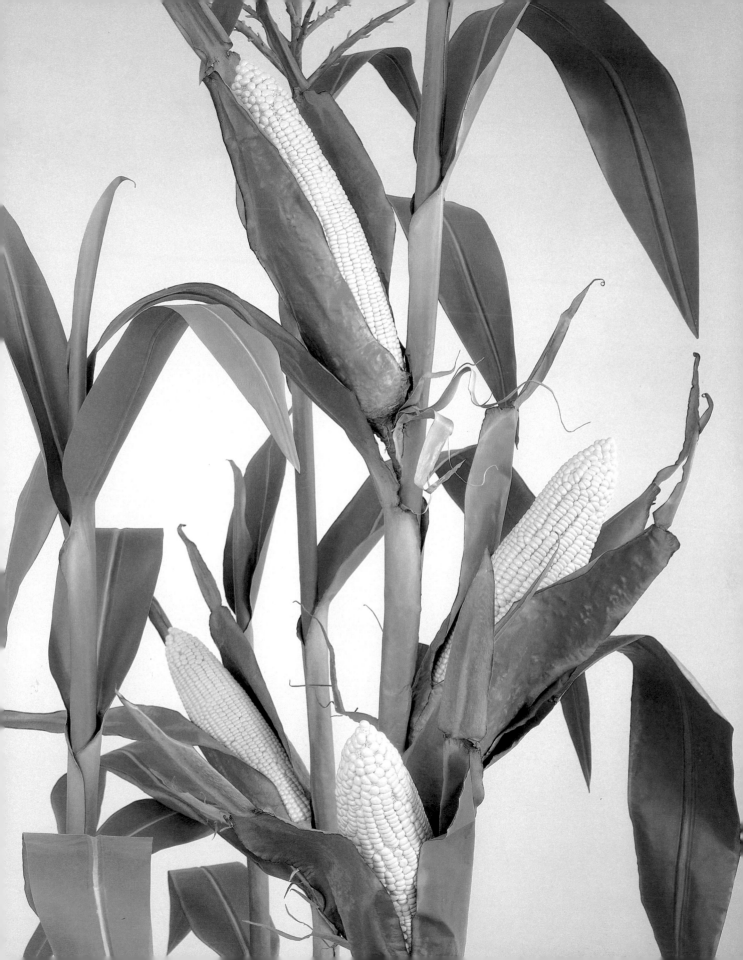

Still from **Slow-Mo**, 1996
Videotape, black-and-white, silent; 9 minutes, 48 seconds

Borinquen Lacers with **Unlaced Atlas/Mundillo Desencajado I (Europe)**, 1996
Interpreted and fabricated by the Borinquen Lacers, San Juan, Puerto Rico
Cotton thread, approximately 60 x 84 in. (152.4 x 213.4)

Antonio Martorell

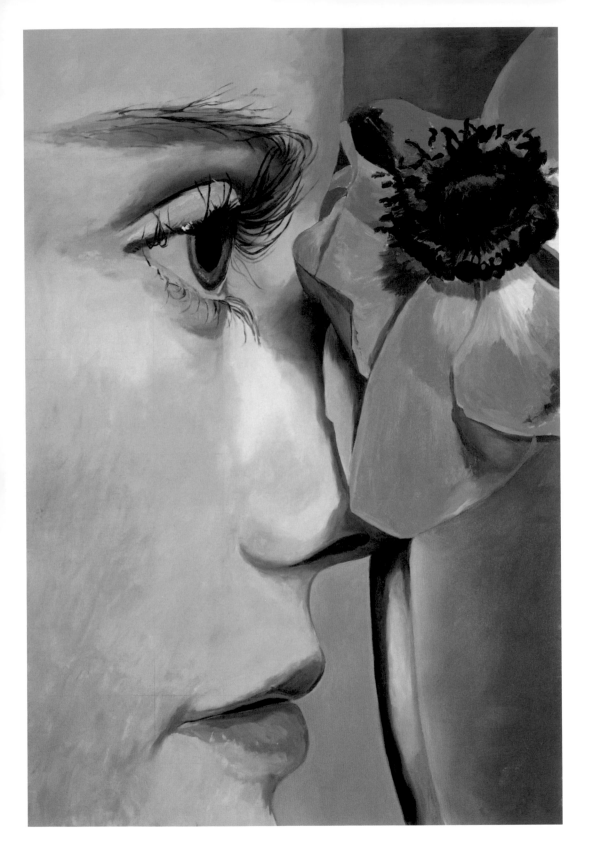

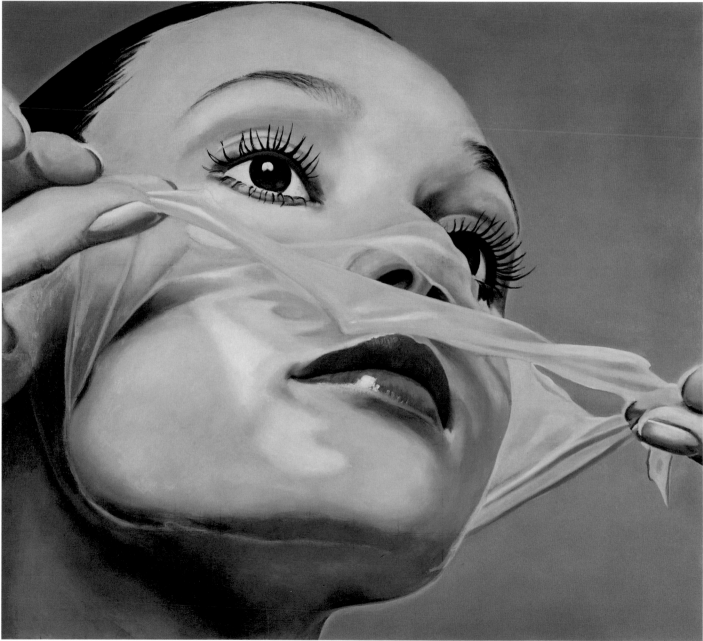

Sniffing the Stem, 1996
Oil on linen, 72 x 48 in. (182.9 x 121.9 cm)

Peel, 1996
Oil on linen, 78 x 86 1/4 in. (198.1 x 219.1 cm)
Collection of Dr. Richard and Mrs. Daria Feinstein

Richard Phillips 163

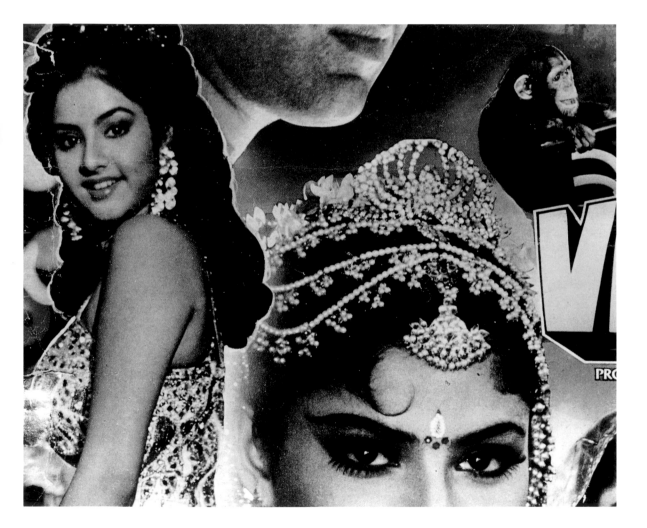

166 **Shashwati Talukdar**

Still from **My Life as a Poster**, 1995
16mm film, color, sound; 7 minutes, 30 seconds

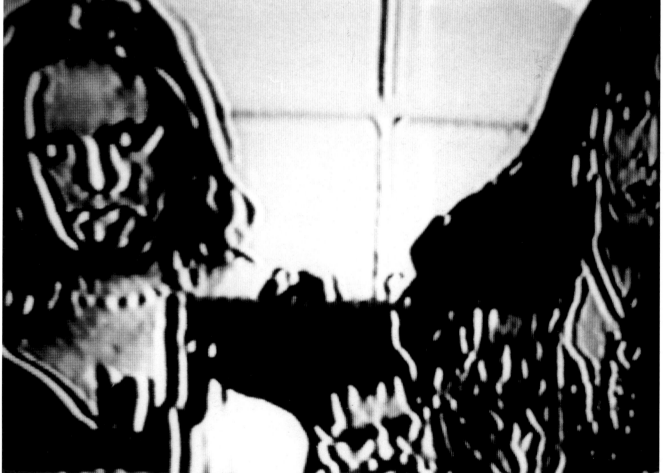

Still from **Ladies There's a Space You Can't Go**, 1995
Videotape, color, sound; 6 minutes

Laura Parnes 167

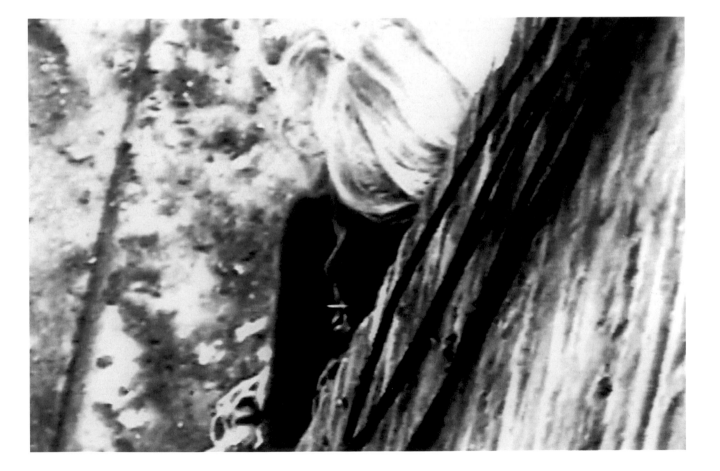

168 **Leah Gilliam**

Still from **Sapphire and the Slave Girl**, 1995
Videotape, black-and-white, sound; 17 minutes

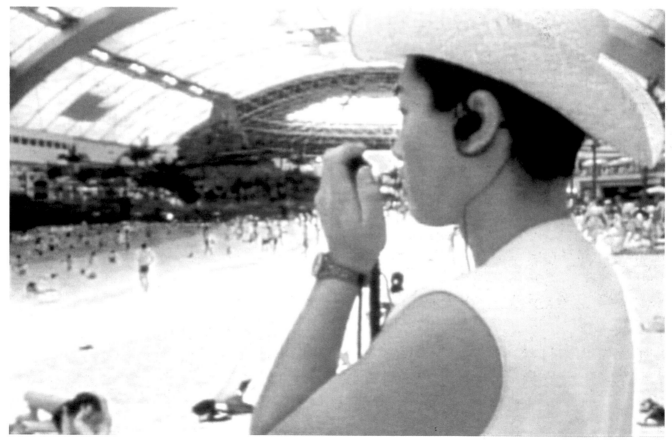

Still from **Synthetic Pleasures**, 1996
35mm, color, sound; 83 minutes

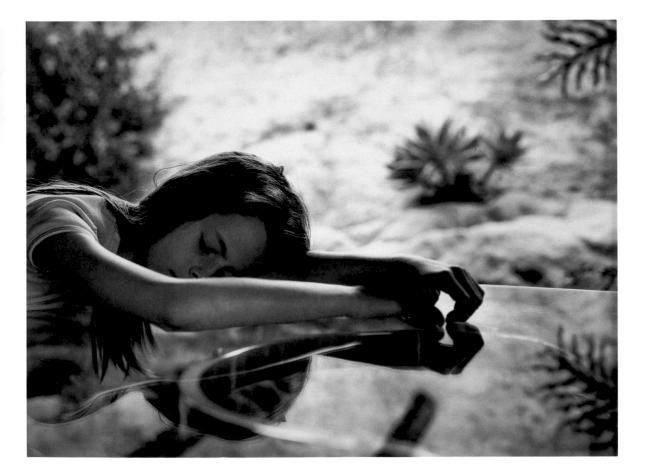

170 **Sharon Lockhart**

Untitled, 1996
C-print, edition of 6, 32 x 43 in. (81.3 x 109.2 cm)
Collection of Andrew Ong

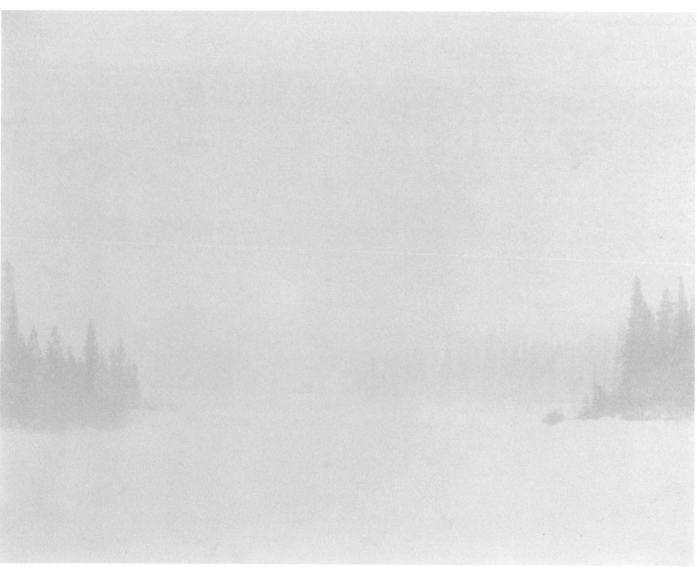

Untitled, 1996
C-print, edition of 6, 49 x 61 1/8 in. (124.5 x 155.3 cm)
Whitney Museum of American Art, New York;
Promised gift of Mrs. Melva Bucksbaum

171

Charles Burnett

Still from **The Glass Shield**, 1995
35mm film, color, sound; 110 minutes

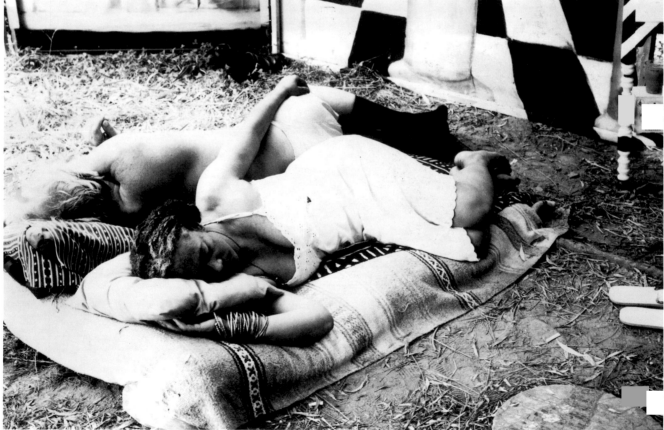

Still from **B/side**, 1996
16mm film, black-and-white and color, sound; 38 minutes

Abigail Child 173

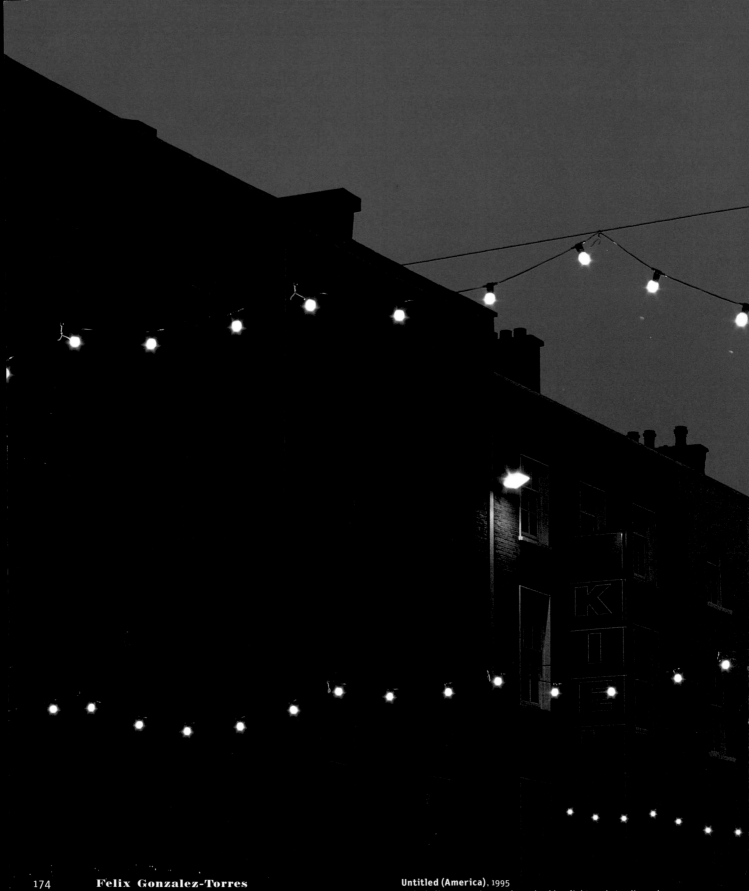

174 **Felix Gonzalez-Torres**

Untitled (America), 1995
Light bulbs, extension cords, and rubber light sockets, dimensions vary
Whitney Museum of American Art, New York; Purchase, with funds
from the Contemporary Painting and Sculpture Committee 96.74a-l

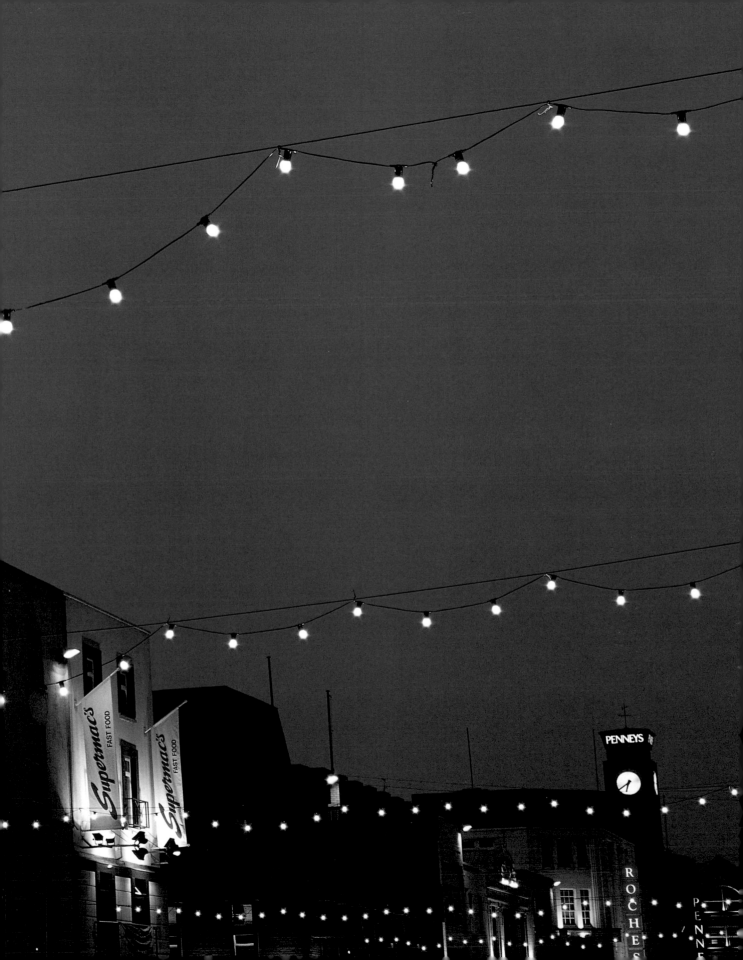

Index of Artists' Plates

Unless otherwise indicated, illustrated works are in the collection of the artist.

Artists' Biographies

Doug Aitken

Born in Redondo Beach, California, 1968
Lives in Los Angeles, California, and New York, New York
Studied at Marymount Palos Verdes College, California (1986-87);
Art Center College of Design, Pasadena, California (BFA, 1991)

1997 303 Gallery, New York*

1996 "Campo 6: The Spiral Village," Galleria Civica D'Arte
 Moderne e Contemporanea Turin, Italy,
 and Bonnefanten Museum, Maastricht, The
 Netherlands
 "The Fifth Annual New York Video Festival," New York
 Taka Ishii Gallery, Tokyo, Japan*

1995 "La belle et la bête: Un choix de jeunes artistes
 américains," Musée d'Art Moderne de la Ville de
 Paris, France

Roman Anikushin and Bob Paris

Roman Anikushin

Born in Moscow, Soviet Union, 1975
Lives in Moscow
Currently attends the Russian Humanitarian University, Moscow

Bob Paris

Born in Columbus, Ohio, 1959
Lives in New York, New York
Studied at the University of California, Berkeley (BA, 1983;
MJ, 1989)

1996 "The Fifth Annual New York Video Festival," New York
 "Pandaemonium: London Festival of Moving Images,"
 England
 "You Call That a Music Video?," Northwest Film
 Center, Portland Art Museum, Oregon

1995 "International Hamburg Short Film Festival," Germany
 "Ninth Annual Dallas Video Festival," Dallas Museum
 of Art, Texas

Michael Ashkin

Born in Morristown, New Jersey, 1955
Lives in New York, New York
Studied at the University of Pennsylvania, Philadelphia (BA, 1977);
Columbia University, New York (MA, 1980); The Art Institute of
Chicago, Illinois (MFA, 1993)

1996 Bronwyn Keenan Gallery, New York, New York*
 "Constructions," Michael Klein Gallery, New York,
 New York
 Feigen, Inc., Chicago, Illinois*
 "Space, Mind, Place," Andrea Rosen Gallery, New York,
 New York

1995 Bronwyn Keenan Gallery, New York, New York
 (Michael Ashkin and Brad Kalhamer)

Robert Attanasio

Born in New York, New York, 1952
Lives in New York
Studied at City College, New York (BA, 1975)

1996 "As Seen on TV," Artists' Television Access, San
 Francisco, California
 "The Fifth Annual New York Video Festival," New York
 "New Visions Third International Festival
 of Audio-Visual Culture," Glasgow, Scotland

1995 "International Audio-Visual Experimental Festival,"
 Arnhem, The Netherlands
 "New York Underground Film Festival," New York

Burt Barr

Born in Lewiston, Maine, 1938
Lives in New York, New York
Studied at Boston University, Massachusetts (BA, 1962); San
Francisco Art Institute, California (1965-68)

1996 Paula Cooper Gallery, New York, New York*
 "Smooch," Bermuda Editions, New York, New York*
 Springdance Cinema of Utrecht, Amsterdam,
 The Netherlands
 "Twelve Ton Rose," (costume design for Trisha Brown
 Dance Company) Brooklyn Academy of Music,
 New York

1995 "La Mare (The Pool)," Connecticut Public Television and
 Radio, Hartford

Zoe Beloff

Born in Belfast, Ireland, 1958
Lives in New York, New York
Studied at Edinburgh University, College of Art, Painting, and
Art History, Scotland (MA, 1980); Columbia University, New York
(MFA, 1983); Whitney Museum of American Art Independent
Study Program, New York (1985-86)

1996 "14th World Wide Video Festival," The Hague,
The Netherlands
"45th Melbourne International Film Festival," Australia
"3a Mostra de Video Independent," Barcelona, Spain
"Total Mobile Home Micro Cinema," San Francisco,
California*
University Art Museum and Pacific Film Archive,
University of California, Berkeley*

Douglas Blau

Born in Los Angeles, California, 1955
Lives in New York, New York
Studied at Washington University, St. Louis, Missouri (BA, 1977;
BFA, 1977); University of California, Los Angeles (1978-79)

1996 "a/drift," Center for Curatorial Studies Museum, Bard
College, Annandale-on-Hudson, New York
"Art and Film Since 1945: Hall of Mirrors," The Museum
of Contemporary Art, Los Angeles, California
(traveled)

1994 "Douglas Blau, David Deutsch, James Welling,"
Jay Gorney Modern Art, New York, New York
"Stills," The Museum of Modern Art, New York,
New York*
"The World of Tomorrow," Thomas Solomon's Garage,
Los Angeles, California*

Louise Bourgeois

Born in Paris, France, 1911
Lives in New York, New York
Studied at Université de la Sorbonne, Paris (1932-35); École
du Louvre, Paris (1936-37); École des Beaux-Arts, Paris (1936-38);
Atelier Bissière, Paris (1936-37); Académie de la Grande
Chaumière, Paris (1937-38); Atelier Fernand Léger, Paris (1938);
Atelier Vaclav Vytlacil, Paris (1939-40)

1996 "Drawings," University Art Museum and Pacific
Film Archive, University of California, Berkeley
(traveling)*
"Universalis: 23. Bienal de São Paulo," Brazil

1995 "Escultura de Louise Bourgeois: La Elegancia
de la Ironía," Museo de Arte Contemporáneo de
Monterrey, Mexico (traveled)*
National Gallery of Victoria, Melbourne, Australia
(traveled)*
"Sculpture," and "The Prints of Louise Bourgeois,"
Museum of Modern Art, Oxford, England
(traveling)*

1994 "Locus of Memory," The Brooklyn Museum, New York
(traveled)*

Chris Burden

Born in Boston, Massachusetts, 1946
Lives in Topanga Canyon, California
Studied at Pomona College, Claremont, California (BFA, 1969);
University of California, Irvine (MFA, 1971)

1996 "Beyond the Limits: Machines & Models. Power,
Time, Distance," MAK-Österreichisches Museum
für Angewandte Kunst, Vienna, Austria*
"Out of the Museum," Galerie Krinziger, Vienna,
Austria*
"Three Ghost Ships," Gagosian Gallery, Beverly Hills,
California*

1995 Centre d'Art Santa Mònica, Barcelona, Spain*
Frac Languedoc-Roussillon, Montpellier, France*

Bureau of Inverse Technology

Incorporated 1992

1996 "The Fifth Annual New York Video Festival," New York
"Memesis: Ars Electronica Festival 96," Linz, Austria
"Ultras.nd: A Sperm Economy," Blasthaus, San
Francisco, California*

1995 "Other Cinema," Artists' Television Access, San
Francisco, California

Charles Burnett

Born in Vicksburg, Mississippi, 1944
Lives in Los Angeles, California
Studied at Los Angeles City College (AA, 1967); University of
California, Los Angeles (BA, 1969; MFA, 1974)

1997 "The Films of Charles Burnett: Witnessing for
Everyday Heroes," The Walter Reade Theater at
Lincoln Center, New York
"26th International Film Festival Rotterdam,"
The Netherlands

1996 "Festival internazionale del film Locarno," Switzerland

1995 "39th London Film Festival," England
"Toronto International Film Festival," Canada

Vija Celmins

Born in Riga, Latvia, 1938
Lives in New York, New York
Studied at the John Herron Institute, Indianapolis, Indiana (BFA,
1962); University of California, Los Angeles (MFA, 1965)

1997 "Birth of the Cool: American Painting from Georgia
O'Keeffe to Christopher Wool," Deichtorhallen,
Hamburg, Germany (traveling)

1996 "Night Sky Paintings and Drawings, 1994-1996," McKee
Gallery, New York, New York*
"Works: 1964-96," Institute of Contemporary Arts,
London, England (traveling)

1995 "About Place: Recent Art of the Americas," The Art
Institute of Chicago, Illinois
Fondation Cartier pour l'Art Contemporain, Paris,
France*

Abigail Child

Born in Newark, New Jersey, 1950
Lives in New York, New York
Studied at Harvard University, Cambridge, Massachusetts (BA,
1968); Yale University, New Haven, Connecticut (MFA, 1970)

1996 "40th London Film Festival," England*
"SoundCulture 96/Alternative Visions," University
Art Museum and Pacific Film Archive, University of
California, Berkeley

1995 "Filmmakers im Filmhaus," Die Filmreihe der Austria
im Filmhaus am Spittelberg*
London Filmmakers Co-op, England*
"Pleasure Dome Spring Film and Video," Toronto,
Canada*

Francesco Clemente

Born in Naples, Italy, 1952
Lives in New York, New York, and Madras, India

1996 Gagosian Gallery, Beverly Hills, California*
"Paintings of the Gate," Gallery Bruno Bischofberger,
Zurich, Switzerland*
Stadtische Galerie Altes Theater, Ravensburg,
Germany*

1995 "Ex Libris Chenonçeau," Chateau de Chenonçeau,
France*
"Frescos and Pastels, 1970-1995," Anthony d'Offay
Gallery, London, England*

Bruce Conner

Born in McPherson, Kansas, 1933
Lives in San Francisco, California
Studied at Wichita State University, Kansas (1951-52); University
of Nebraska, Lincoln (BFA, 1956); The Brooklyn Museum Art
School, New York (1956); University of Colorado, Boulder (1957)

1996 Gallery Paule Anglim Gallery, San Francisco, California

1995 "Beat Culture and the New America: 1950-1965,"
Whitney Museum of American Art, New York, New
York (traveled)
"15 Beautiful Mysteries," Kohn Turner Gallery,
Los Angeles, California*
"15 Beautiful Mysteries," Curt Marcus Gallery, New
York, New York*
"Prints, Multiples, Illustrated Books, Films: 1957-1991,"
Susan Inglett, New York, New York*

Bryan Crockett

Born in Santa Barbara, California, 1970
Lives in New York, New York
Studied at the Cooper Union for the Advancement of Science and Art, School of Art, New York (BFA, 1992); Yale University, School of Sculpture, New Haven, Connecticut (MFA, 1994)

1997 "Dead Fit Beauty," Bertha and Karl Leubsdorf
 Art Gallery, Hunter College, New York, New York

1996 "Imaginary Anatomy," Pasinger Fabrik,
 Munich, Germany
 "Psy-Fi," Real Art Ways, Hartford, Connecticut

1995 "Customized Terror," Artists Space, New York,
 New York
 Friedrich Petzel Gallery, New York, New York

Cultural Alchemy

Howard Goldkrand
Born in Fort Riley, Kansas, 1969
Lives in New York, New York
Studied at Wesleyan University, Middletown, Connecticut, and Oxford University, England (BA, 1992)

Beth Coleman
Born in New York, New York, 1969
Lives in New York
Studied at Yale University, New Haven, Connecticut (BA, 1989); Graduate Center, City University of New York (MA, 1995); New York University (Ph.D. in progress)

Beth Coleman and Howard Goldkrand created Cultural Alchemy in 1995, mixing conceptual art with youth culture and nonlinear narrative as environmental design. A major player in the experimental "Illbient" scene, Cultural Alchemy's ongoing projects include SoundLab, an erratic and nomadic event based on DJ culture, with live electronic mixing of sound and image; and Foundation Analysis, an investigation of the sound-constructed environment. Recent Cultural Alchemy events include:

1995 "Crush City SoundClash," with DJ Spooky
 That Subliminal Kid and Alec Empire, New York,
 New York
 "International Yoni Crush City Tour," New York,
 New York, and Berlin, Germany

1996 "Bass in the Bridge," Brooklyn Bridge Anchorage
 presented by Creative Time, Brooklyn, New York
 "Offbeat, A Red Hot Happening," New York, New York
 SoundLab at Recombinant Festival, Los Angeles,
 California, San Francisco, California, and Seattle,
 Washington

Philip-Lorca diCorcia

Born in Hartford, Connecticut, 1953
Lives in New York, New York
School of the Museum of Fine Arts, Boston, Massachusetts (Postgraduate Certificate, 1976; Diploma, 1975); Yale University, New Haven, Connecticut (MFA, 1979)

1996 Galerie Klemens Gasser, Cologne, Germany*
 "Street Work," PaceWildensteinMacGill, New York,
 New York*
 Theoretical Events, Naples, Italy*

1995 Art & Public, Geneva, Switzerland*
 "Boston School," The Institute of Contemporary Art,
 Boston, Massachusetts

Cheryl Dunye

Born in Monrovia, Liberia, 1966
Lives in Pomona, California
Studied at Michigan State University, East Lansing (1984-86); Temple University, Philadelphia, Pennsylvania (BA, 1990); Rutgers—The State University, New Brunswick, New Jersey (MFA, 1992)

1996 "8e Festival International," Paris, France
 "11o Festival Internazionale di Film con Tematiche
 Omusessuali," Turin, Italy
 "Internationale Filmfestpiele Berlin," Germany
 "San Francisco International Lesbian and Gay Film
 Festival," California
 "Toronto International Film Festival," Canada

Sam Easterson

Born in Hartford, Connecticut, 1972
Lives in Minneapolis, Minnesota
Studied at the Cooper Union for the Advancement of Science & Art (BFA, 1994); University of Minnesota at Minneapolis (MA, expected 1999)

1996 "Fuzzy Logic," The Institute of Contemporary Art,
 Boston, Massachusetts
 "Video Collections," 4C, New York, New York
 "Video Shag," Shag Bar, Toronto, Canada

Wendy Ewald

Born in Detroit, Michigan, 1951
Lives in Rhinebeck, New York
Studied at Antioch University, Yellow Springs, Ohio (BA, 1974)

1996 Addison Gallery of American Art, Phillips Academy,
 Andover, Massachusetts (traveling)*

1995 "Portraits and Dreams/Retratos y Sueños: Photographs
 by Mexican Children," The Snite Museum of Art,
 University of Notre Dame, South Bend, Indiana*
 "Visions of Childhood," Center for Curatorial Studies,
 Bard College, Annandale-on-Hudson, New York

1994 "Projects and Photographs," James Danziger Gallery,
 New York, New York*
 "Projects and Photographs," Juanita Kreps Gallery,
 Center for Documentary Studies at
 Duke University, Durham, North Carolina*

William Forsythe

Born in New York, New York, 1949
Lives in Frankfurt am Main, Germany
Studied in the United States with Nolan Dingman, Christa Long,
Jonathan Watts, Maggie Black, Finis Jung, William Griffith, and
Meredith Baylis (1968-1973)

Artistic director of the Ballett Frankfurt, Germany, since 1984.
His works include *The Vile Parody of Address*, *In the Middle,
Somewhat Elevated*, *Limb's Theorem*, *The Loss of Small Detail*,
Alie/na(c)tion, and *Eidos : Telos*, and they appear in many
international repertories including the Paris Opéra, the New York
City Ballet, the Royal Ballet, The Nederlands Dans Theater,
the San Francisco Ballet, the National Ballet of Canada, and the
Compañía Nacional de Danza.

Leah Gilliam

Born in Washington, D.C., 1967
Lives in Rhinebeck, New York
Studied at Brown University, Providence, Rhode Island (BA, 1989);
University of Wisconsin-Milwaukee (MFA, 1991)

1996 "The Fifth Annual New York Video Festival," New York
 "1996 Charlotte Film & Video Festival," North Carolina
 "39th San Francisco International Film Festival,"
 California
 "University Art Museum and Pacific Film Archive,"
 University of California, Berkeley

1995 "Mix 95: 9th New York Lesbian & Gay Experimental
 Film/Video Festival," New York

Michael Gitlin

Born in Bluffton, Indiana, 1956
Lives in New York, New York
Studied at Indiana University at Bloomington (BA, 1978); Bard
College, Annandale-on-Hudson, New York (MFA, 1994)

1996 "45th International Mannheim-Heidelberg Film
 Festival," Germany
 Massart Film Society, Boston, Massachusetts*

1995 "Rainy States Film Festival," Seattle, Washington

Felix Gonzalez-Torres

1958 Guaimaro, Cuba—Miami, Florida 1996
Lived in New York, New York; died in Miami
Studied at Pratt Institute, New York (BFA, 1983); Whitney
Independent Studio Program, New York (1983); International
Center for Photography, New York University (1987)

1996 "Felix Gonzalez-Torres (Girlfriend in a Coma)," Musée
 d'Art Moderne de la Ville de Paris, France*

1995 Akademie der Bildenden Künste, Munich, Germany
 (with Roni Horn), organized by Sammlung Goetz,
 Munich, Germany
 "Felix Gonzalez-Torres (A Possible Landscape),"
 Centro Galego de Arte Contemporaneo, Santiago de
 Compostela, Spain*
 Andrea Rosen Gallery, New York, New York*
 The Solomon R. Guggenheim Museum, New York,
 New York*

Dan Graham

Born in Urbana, Illinois, 1942
Lives in New York, New York

1996 Galerie Micheline Szwajcer, Antwerp, Belgium*
 "Models to Projects, 1978-1995," Marian Goodman
 Gallery, New York, New York*
 "Pavillons," Städtische Galerie, Nordhorn, Germany*

1995 "1965-1975: Reconsidering the Object of Art,"
 The Museum of Contemporary Art, Los Angeles,
 California
 "Public Information: Desire, Disaster, Document,"
 San Francisco Museum of Modern Art, California

David Hammons

Born in Springfield, Illinois, 1943
Lives in New York, New York
Studied at Los Angeles Trade-Technical College, California (1964-65); Chouinard Art Institute, Los Angeles (1966-68); Otis Art Institute of the Parsons School of Design, Los Angeles (1968-72)

1996 "Marks: Artists' work throughout Jerusalem," The Israel Museum, Jerusalem

1995 "Been There and Back," Salzburger Kunstverein, Salzburg, Austria*
"Fuoriuso," Pescara, Italy
"Ripple Across the Water 95," Watari-Um, The Watari Museum of Contemporary Art, Tokyo, Japan

1994 Sara Penn/Knobkerry, New York, New York*

Ken Jacobs

Born in New York, New York, 1933
Lives in New York
Studied at the Hans Hofmann School of the Arts, New York (1956-58)

1997 "Internationale Filmfestspiele Berlin," Germany

1996 "Hall of Mirrors: Art and Film Since 1945," The Museum of Contemporary Art, Los Angeles, California
Oesterreichisches Filmmuseum, Vienna, Austria
"Radical Jewish Culture," Merkin Concert Hall, Elaine Kaufman Cultural Center, New York, New York
"Wrong Turn into Adventure: The Film-Performance Art of Ken Jacobs," The Museum of Modern Art, New York, New York*

Ilya Kabakov

Born in Dnepropetrovsk, Soviet Union, 1933
Lives in New York, New York, Moscow, Russia, and Paris, France
Studied at Moscow Art School, V.A. Sourikov Art Academy (1951-57)

1996 "Ilya Kabakov, Storyteller," Køge Bugt Kulturhus, Copenhagen, Denmark
"The Reading Room," Deichtorhallen Hamburg, Germany*
"Sur le toit/Op het dak," Palais des Beaux-Arts, Brussels, Belgium*
"Universalis: 23. Bienal Internacional São Paulo," Brazil

1995 "C'est ici que nous vivons," Centre Georges Pompidou, Paris, France*

Martin Kersels

Born in Los Angeles, California, 1960
Lives in Los Angeles
Studied at the University of California, Los Angeles (BA, 1984; MFA, 1995)

1996 "Defining the Nineties: Consensus-making in New York, Miami, and Los Angeles," Museum of Contemporary Art, Miami, Florida
Jay Gorney Modern Art, New York, New York*
"The Power of Suggestion: Narrative and Notation in Contemporary Drawing," The Museum of Contemporary Art, Los Angeles, California

1995 Dan Bernier Gallery, Santa Monica, California*
"La belle et la bête: Un choix de jeunes artistes américains," Musée d'Art Moderne de la Ville de Paris, France

Annette Lawrence

Born in New York, New York
Lives in Denton, Texas
Studied at the University of Hartford, West Hartford, Connecticut (BFA, 1986); Hoffberger School of Painting, Maryland Institute College of Art, Baltimore (MFA, 1990)

1996 "Circus/Juice," Art League of Houston, Texas*
"Same Way," Gerald Peters Gallery, Dallas, Texas*
"The Texas Collection of The Museum of Fine Arts, Houston: Texas Modern and Post-Modern," The Museum of Fine Arts, Houston, Texas

1995 "Re-Collections," Project Row Houses, Houston, Texas
"Same Way: Drawings by Annette Lawrence," ArtPace, The Pace Roberts Foundation for Contemporary Art, San Antonio, Texas*

Iara Lee

Born in São Paulo, Brazil, 1966
Lives in New York, New York
Studied at New York University (BFA, 1993)

1996 "Cinemateca Uruguay," Montevideo
"Internationale Filmfestspiele Berlin," Germany
"Sundance Film Festival," (feature selection), Park City, Utah
"39th San Francisco International Film Festival," California

1995 "Toronto International Film Festival," Canada

Zoe Leonard

Born in Liberty, New York, 1961
Lives in New York, New York

1997 Kunsthalle Basel, Switzerland (traveling)*
 "Zoe Leonard," Museum of Contemporary Art, Miami,
 Florida*

1995 Galerie Jennifer Flay, Paris, France*
 "In a Different Light," University Art Museum and
 Pacific Film Archive, University of California,
 Berkeley
 "Photographs & Objects," Paula Cooper Gallery, New
 York, New York (presented at 131 Essex Street)*

Sharon Lockhart

Born in Norwood, Massachusetts, 1964
Lives in Los Angeles, California
Studied at San Francisco Art Institute, California (BA, 1991); Art
Center College of Design, Pasadena, California (MFA, 1993)

1996 Blum & Poe Gallery, Los Angeles, California*
 "Persona," The Renaissance Society at The University of
 Chicago, Illinois (traveled)
 Friedrich Petzel Gallery, New York, New York*

1995 "La belle et la bête: Un choix de jeunes artistes
 américains," Musée d'Art Moderne de la Ville de
 Paris, France
 Künstlerhaus Stuttgart, Germany (with Liam Gillick)*

Charles Long

Born in Long Branch, New Jersey, 1958
Lives in New York, New York
Studied at the Philadelphia College of Art, Pennsylvania (BFA, 1981);
Yale University, New Haven, Connecticut (MFA, 1988)

1997 "Performance Anxiety," Museum of Contemporary Art,
 Chicago, Illinois

1996 "Defining the Nineties: Consensus-making in
 New York, Miami, and Los Angeles," Museum of
 Contemporary Art, Miami, Florida
 "Our Bodies, Our Shelves," Shoshana Wayne Gallery,
 Santa Monica, California*
 "Young Americans: New American Art in the Saatchi
 Collection: Part I," Saatchi Gallery, London,
 England

1995 "The Amorphous Body Study Center," Tanya Bonakdar
 Gallery, New York, New York (with Stereolab)*

Kristin Lucas

Born in Davenport, Iowa, 1968
Lives in New York, New York
Studied at the Cooper Union for the Advancement of Science & Art,
New York (BFA, 1994)

1997 "Young and Restless," The Museum of Modern Art, New
 York, New York

1996 "The Fifth Annual New York Video Festival," New York
 "Mr. Dead and Mrs. Free: The History of Squat
 Theatre," Artists Space, New York, New York
 "Panzerotti Five," Free Parking, Toronto, Canada
 "TechnoCASUALTIES," Artists' Television Access, San
 Francisco, California

Paul McCarthy

Born in Salt Lake City, Utah, 1945
Lives in Los Angeles, California
Studied at the San Francisco Art Institute, California (BFA, 1969);
University of Southern California, Los Angeles (MFA, 1973)

1997 "Performance Anxiety," Museum of Contemporary Art,
 Chicago, Illinois

1996 "The Comic Depiction of Sex in American Art," Galerie
 Andreas Binder, Munich, Germany
 "Yaa-Hoo," Luhring Augustine, New York, New York*

1995 "Pinocchio: Pipenose Householddilemma," Air de Paris,
 Nice, France (traveled)*
 "Projects 51," The Museum of Modern Art, New York,
 New York*

Kerry James Marshall

Born in Birmingham, Alabama, 1955
Lives in Chicago, Illinois
Studied at Otis School of Art & Design, Los Angeles, California
(BFA, 1978)

1997 "New Paintings," Addison Gallery of American Art,
 Phillips Academy, Andover, Massachusetts*

1996 "No Doubt: African American Art of the 90s," The
 Aldrich Museum of Contemporary Art, Ridgefield,
 Connecticut
 "Real: Figurative Narratives in Contemporary African-
 American Art," Bass Museum of Art, Miami Beach,
 Florida

1995 "About Place: Recent Art of the Americas," The Art
 Institute of Chicago, Illinois
 "The Garden Project," Jack Shainman Gallery, New
 York, New York (traveled)*

Antonio Martorell

Born in Santurce, Puerto Rico, 1939
Lives in Cayey, Puerto Rico, and New York, New York
Studied with Julio Martín-Caro, Madrid, Spain, under the auspices
of the Ferré Foundation (1961-62); Taller de Gráfica del Instituto de
Cultura Puertorriqueña (1962-65)

1996 "Container-96: Art Across the Oceans, 14 Latin
 American Artists," Copenhagen, Denmark
 "Direcciones," Museo de Arte de Ponce, Puerto Rico
 (traveling)
 "Domestic Partnerships: New Impulses in Decorative
 Arts from the Americas," Art in General, New York,
 New York
 "Embedded Metaphor," John and Mable Ringling
 Museum of Art, Sarasota, Florida (traveled)
 "Interzones: A Work in Progress," Kunstforeningen,
 Copenhagen, Denmark (traveled)

Amanda Miller

Born in Chapel Hill, North Carolina, 1961
Lives in New York, New York, and Freiburg, Germany
Studied in the United States (1977-82) with Wilhelm Burmann,
Alfonso Cata, Bobbie Blankshine, Jacques D'Amboise,
Christine Wright, Maggie Black, and Zena Rommett. Resident
choreographer at Ballett Frankfurt, Germany (1986-92).

Newly appointed artistic director of Ballett Freiburg, Germany,
and, since 1993, artistic director of Pretty Ugly Dancecompany, an
international ensemble of freelance dancers which functions on a
residency basis. Her works include *Un Petit d'un Petit*, *Meidosems*,
Paralipomena, *The Previous Evening*, and *Two Pears*. They
have been performed by PUDC in theaters and festivals throughout
Europe, the United States, India, and Canada.

Paul D. Miller

Born in Washington, D.C., 1970
Studied at Bowdoin College, Brunswick, Maine (BA, 1992)
Lives in New York, New York

1997 "Mille Plateaux Artists," Berlin, Germany (touring)
 "Playing the Orchestra," with Ryuichi Sakamoto, Tokyo,
 Japan (touring)

1996 "Death in the Light of the Phonograph: Excursions
 into the Pre-Linguistic," Annina Nosei Gallery, New
 York, New York
 "Kraanerg," by Xenakis (with the XTS Ensemble),
 New York, New York
 "Recombinant," Los Angeles (touring)

1995- SoundLab, New York, New York

Christopher Münch

Born in Los Angeles, California, 1962
Lives in Los Angeles

1996 "Festival internazionale del film Locarno," Switzerland
 "Filmfest Hamburg," Germany
 "New Directors/New Films," The Film Society of
 Lincoln Center and The Museum of Modern Art,
 New York, New York
 "Sundance Film Festival," Park City, Utah
 "Toronto International Film Festival," Canada

Bruce Nauman

Born in Fort Wayne, Indiana, 1941
Lives in Galisteo, New Mexico
Studied at the University of Wisconsin-Madison (BA, 1964);
University of California, Davis (MFA, 1966)

1996 "Fifteen Pairs of Hands, White Bronze, & 'End of the
 World' with Lloyd Maines," Leo Castelli, New York,
 New York*
 Konrad Fischer, Düsseldorf, Germany*
 Magasin, Stockholm Konsthall, Sweden*
 "Video & Sculpture," Sperone Westwater, New York,
 New York*

1995 "Elliot's Stones," Museum of Contemporary Art,
 Chicago, Illinois*

1994 Walker Art Center, Minneapolis, Minnesota, in associa-
 tion with the Hirshhorn Museum and Sculpture
 Garden, Smithsonian Institution, Washington, D.C.
 (traveled)*

Gabriel Orozco

Born in Veracruz, Mexico, 1962
Lives in New York, New York
Studied at the Escuela Nacional de Arte Plasticas, U.N.A.M, Mexico
City, Mexico (1984); Circulo de Bellas Artes, Madrid, Spain (1987)

1996 "Empty Club," 1996 Artangel/Beck's Commission,
 London, England*
 Marian Goodman Gallery, New York, New York*
 Kunsthalle Zürich, Switzerland (traveled)*

1995 "Kwangju Biennale: Beyond the Borders," Seoul, Korea
 Galerie Micheline Szwajcer, Antwerp, Belgium*

Tony Oursler

Born in New York, New York, 1957
Lives in New York
Studied at the California Institute of the Arts, Valencia (BFA, 1979)

1996 Lisson Gallery, London, England*
 Metro Pictures, New York, New York*

1995 "Carnegie International 1995," The Carnegie Museum of
 Art, Pittsburgh, Pennsylvania
 Centre d'Art Contemporain, Geneva, Switzerland*
 Stedelijk Van Abbemuseum, Eindhoven, The
 Netherlands*

1994 Portikus, Frankfurt am Main, Germany*

Laura Parnes

Born in Buffalo, New York, 1968
Lives in New York, New York
Studied at the Tyler School of Art, Temple University, Philadelphia,
Pennsylvania (BFA, 1990)

1996 "In the Flow: Alternate Authoring Strategies," Franklin
 Furnace, New York, New York
 Chassie Post Gallery, New York, New York
 "Simpler," Gavin Brown's Enterprise, New York, New
 York
 "The Sit In," The Institute for Contemporary Art,
 P.S. 1 Museum and The Clocktower Gallery, Long
 Island City, New York

1995 "Other Rooms," Ronald Feldman Fine Arts, New York,
 New York

Jennifer Pastor

Born in Hartford, Connecticut, 1966
Lives in Los Angeles, California
Studied at the School of Visual Arts, New York, New York (BFA,
1988); University of California, Los Angeles (MFA, 1992)

1996 Museum of Contemporary Art, Chicago, Illinois
 (traveled)*
 "Universalis: 23. Bienal Internacional São Paulo," Brazil

1995 Studio Guenzani, Milan, Italy*

1994 Richard Telles Fine Art, Los Angeles, California*

Raymond Pettibon

Born in Tucson, Arizona, 1957
Lives in Los Angeles, California
Studied at the University of California, Los Angeles (BA, 1977)

1997 "Sunshine & Noir: Art in Los Angeles 1960-1997,"
 Louisiana Museum of Modern Art, Humlebaek,
 Denmark (traveling)

1996 "Chaos, Wahnsinn: Permutationen der zeitgenössischen
 Kunst," Kunsthalle Krems, Austria
 Tramway, Glasgow, Scotland*

1995 Kunsthalle Bern, Switzerland (traveled)*
 Regen Projects, Los Angeles, California*

Richard Phillips

Born in Marblehead, Massachusetts, 1962
Lives in New York, New York
Studied at Massachusetts College of Art, Boston (BFA, 1984); Yale University School of Art, New Haven, Connecticut (MFA, 1986)

1997 "New Paintings," Turner & Runyon Gallery, Dallas, Texas*

1996 Edward Thorp Gallery, New York, New York*
"Painting into Photography, Photography into Painting," Museum of Contemporary Art, Miami, Florida
"Transfixed," Gavin Brown's Enterprise, New York, New York*

1995 "Knoxville Paintings," Edward Thorp Gallery, New York, New York*

Lari Pittman

Born in Los Angeles, California, 1952
Lives in Los Angeles
Studied at the University of California, Los Angeles (1970-73); California Institute of the Arts, Valencia (BFA, 1974; MFA, 1976)

1997 "Sunshine & Noir: Art in Los Angeles 1960-1997," Louisiana Museum of Modern Art, Humlebaek, Denmark (traveling)

1996 "Lari Pittman," Los Angeles County Museum of Art, California (traveled)*
"Lari Pittman: Drawings," University Art Museum, University of California, Santa Barbara (traveled)*
White Cube, London, England*

1995 "Like You," Regen Projects, Los Angeles, California*

Richard Prince

Born in Panama Canal Zone, 1949
Lives in Rensselaerville, New York

1996 "Neue Bilder," Jablonka Galerie, Cologne, Germany*
"Passionsspiele," Haus der Kunst, Munich, Germany*
Maximilian Verlag-Sabine Knust Galerie, Munich, Germany*

1995 Barbara Gladstone Gallery, New York, New York*
Regen Projects, Los Angeles, California*

Charles Ray

Born in Chicago, Illinois, 1953
Lives in Los Angeles, California
Studied at the University of Iowa, Iowa City (BFA, 1975); Mason Gross School of Art, Rutgers—The State University, New Brunswick, New Jersey (MFA, 1979)

1997 "Sunshine & Noir: Art in Los Angeles 1960-1997," Louisiana Museum of Modern Art, Humlebaek, Denmark (traveling)

1996 "Distemper: Dissonant Themes in the Art of the 1990s," Hirshhorn Museum and Sculpture Garden, Smithsonian Institution, Washington, D.C.
"Fashions," Studio Guenzani, Milan, Italy*
"Young Americans: New American Art in the Saatchi Collection: Part II," Saatchi Gallery, London, England

1994 Rooseum-Center for Contemporary Art, Malmö, Sweden (traveled)*

Jason Rhoades

Born in Newcastle, California, 1965
Lives in Los Angeles, California
Studied at the San Francisco Art Institute, California (BFA, 1988); Skowhegan School of Painting and Sculpture, Maine (1988); University of California, Los Angeles (MFA, 1993)

1996 "Defining the Nineties: Consensus-making in New York, Miami, and Los Angeles," Museum of Contemporary Art, Miami, Florida
Kunsthalle Basel, Switzerland*
"Traffic," CAPC, Musée d'Art Contemporain, Bordeaux, France
"Wanås 1996," Stiftelsen Wanås Utställningar, Knislinge, Sweden

1995 "SELFMADE," Grazer Kunstverein, Graz, Austria

Matthew Ritchie

Born in London, England, 1964
Lives in New York, New York
Studied at Camberwell School of Art, London (BFA, 1986); Boston University, Massachusetts (1982)

1996 "Between the Acts," Ice Box, Athens, Greece (traveled)
 "The Hard Way," Basilico Fine Arts, New York,
 New York (traveled)*
 "Screen," Friedrich Petzel, New York, New York

1995 Basilico Fine Arts, New York, New York*
 "A Vital Matrix," Domestic Setting, Los Angeles,
 California

Aaron Rose

Born in New York, New York, 1938
Lives in New York

1995 John Froats Gallery, Cold Spring, New York

Edward Ruscha

Born in Omaha, Nebraska, 1937
Lives in Los Angeles, California
Studied at Chouinard Art Institute, Los Angeles (1956-60)

1996 Gallery Seomi, Seoul, Korea*
 "Hall of Mirrors: Art and Film Since 1945," The Museum
 of Contemporary Art, Los Angeles, California
 (traveling)
 "Vowels: Paintings on Book Covers," Gagosian Gallery,
 Beverly Hills, California*

1995 "Anamorphic Paintings," Leo Castelli Gallery, New York,
 New York*
 The Denver Public Library, Colorado (commissioned
 mural)*

John Schabel

Born in Great Falls, Montana, 1957
Lives in New York, New York
Studied at Middlebury College, Vermont (1975-77); School of Visual Arts, New York (1977-78)

1996 Morris Healy, New York, New York*
 "Passengers," Dan Bernier Gallery, Santa Monica,
 California*
 "Photography," James Graham & Sons, New York,
 New York

1995 "Late Spring," Marc Foxx, Los Angeles, California

Katy Schimert

Born in Grand Island, New York, 1963
Lives in New York, New York
Studied at Philadelphia College of Art, Pennsylvania (BA, 1985); Yale University, New Haven, Connecticut (MFA, 1989)

1997 The Renaissance Society at the University of Chicago,
 Illinois*

1996 "Love on Lake Erie," AC Project Room, New York,
 New York*
 "Universalis: 23. Bienal Internacional São Paulo," Brazil
 "Wanås 1996," Stiftelsen Wanås Utställningar, Knislinge,
 Sweden

1995 "Dear Mr. Armstrong," Janice Guy, New York, New York*

Glen Seator

Born in Beardstown, Illinois, 1959
Lives in New York, New York
Studied at the Cooper Union for the Advancement of Science & Art, New York (1982); Massachusetts College of Art, Boston (BFA, 1984); State University of New York College at Purchase (MFA, 1988)

1997 Capp Street Project, San Francisco, California*

1996 Burnett Miller Gallery, Santa Monica, California
 Kunstraum Wien, Vienna, Austria*
 "29'-0"/East," New York Kunsthalle, New York

1995 "Critical Distance: Between Art and Architecture,"
 Neuberger Museum of Art, State University of New
 York at Purchase

Paul Shambroom

Born in Teaneck, New Jersey, 1956
Lives in Minneapolis, Minnesota
Studied at Minneapolis College of Art and Design (BFA, 1978); Macalester College, St. Paul, Minnesota (1974-75)

1996 "Crossing the Frontier: Photographs of the Developing
 West, 1849 to the Present," San Francisco Museum
 of Modern Art, California
 "Truth and Trials: Color Photography Since 1975,"
 The Minneapolis Institute of Arts, Minnesota

1995 "Face to Face with the Bomb: Nuclear Reality After the
 Cold War," CEPA Gallery, Buffalo, New York*
 "Hidden Places of Power," Walker Art Center,
 Minneapolis, Minnesota*
 "In the Shadow of the Cloud," Portland Art Museum,
 Oregon

David Sherman

Born in Tucson, Arizona, 1966
Lives in San Francisco, California
Studied at Hampshire College, Amherst, Massachusetts (BA, 1988); San Francisco Art Institute (MFA, 1996)

1996 "The British Short Film Festival," London, England
 "European Media Art Festival," Osnabrück, Germany
 "San Francisco International Film Festival," California
 "The 34th New York Film Festival," New York

1995 Total Mobile Home microCINEMA, San Francisco, California

Shahzia Sikander

Born in Lahore, Pakistan, 1969
Lives in Houston, Texas
Studied at the National College of Arts, Lahore (BFA, 1992); Rhode Island School of Design, Providence (MFA, 1995)

1997 Hosfelt Gallery, San Francisco, California*
 "Selections Winter '97," The Drawing Center, New York, New York

1996 "Core 1996 Exhibition," Glassell School of Art, The Museum of Fine Arts, Houston, Texas
 Barbara Davis Gallery, Houston, Texas*
 "Knock, Knock, Who's There? Mithilia, Mithilia Who?," Project Row Houses, Houston, Texas*

Shashwati Talukdar

Born in Dehra Dun, India, 1967
Lives in Philadelphia, Pennsylvania
Studied at Delhi University, India (BA, 1988); Jamia Millia University, New Delhi, India (MA, 1990)

1996 "The Fifteenth Annual Women in the Director's Chair International Film & Video Festival," Chicago, Illinois
 "14th San Francisco International Asian American Film Festival 96," California
 "Margaret Mead Film & Video Festival," American Museum of Natural History, New York, New York
 "Philadelphia Festival of World Cinema," Pennsylvania

1995 "1er Festival Internacional de Video y Artes Electrónicas," Buenos Aires, Argentina

Diana Thater

Born in San Francisco, California, 1962
Lives in Los Angeles, California
Studied at New York University, New York (BA, 1984); Art Center College of Design, Pasadena, California (MFA, 1990)

1996 "China, Crayons & Molly: Numbers 1 Through 10," David Zwirner, New York, New York*
 "Electric Mind," Salzburger Kunstverein, Salzburg, Austria (traveled)*
 "Selected Works 1992-1996," Kunsthalle Basel, Switzerland (traveling)*
 "Jurassic Technologies Revenant: 10th Biennale of Sydney," Australia

1995 "China," The Renaissance Society at the University of Chicago, Illinois (traveled)*

Cecilia Vicuña

Born in Santiago, Chile, 1948
Lives in New York, New York, and Santiago
Studied at the National School of Fine Arts, University of Chile, Santiago (MFA, 1971); Slade School of Fine Arts, University College, London, England (1972-73)

1996 "Inside the Visible: An Elliptical Traverse of 20th Century Art: In, of, and from the Feminine," The Institute of Contemporary Art, Boston, Massachusetts (traveled)
 "Precario," Inverleith House, Royal Botanic Garden, Edinburgh, Scotland*

1994 "ar-'tic-u-late," Mary Delahoyd Gallery, New York, New York
 "Ceque Fragments," The Center for Contemporary Arts of Santa Fe, New Mexico*
 "Hilumbres/Allqa," Begijnhof Sint-Elizabeth, Kortrijk, Belgium*

Kara Walker

Born in Stockton, California, 1969
Lives in Providence, Rhode Island
Studied at Atlanta College of Art, Georgia (BA, 1991); Rhode Island
School of Design, Providence (MFA, 1994)

1997 "New Work," San Francisco Museum of Modern Art,
 California*
 "no place (like home)," Walker Art Center, Minneapolis,
 Minnesota
 The Renaissance Society at the University of Chicago,
 Illinois*

1996 "From the Bowels to the Bosom: A Reconstruction,"
 Wooster Gardens, New York, New York*

1995 "La belle et la bête: Un choix de jeunes artistes
 américains," Musée d'Art Moderne de la Ville de
 Paris, France

T.J. Wilcox

Born in Seattle, Washington, 1965
Lives in New York, New York
Studied at the School of Visual Arts, New York (BFA, 1989); Art
Center College of Design, Pasadena, California (MFA, 1995)

1996 "Affairs," Institut für Gegenwartskunst, Vienna, Austria
 Gavin Brown's Enterprise, New York, New York*
 "Persona," The Rennaissance Society, Chicago, Illinois
 (traveled)
 "Sampler 2," David Zwirner Gallery, New York,
 New York
 "Studio 246," Kunstlerhaus Bethanien, Berlin, Germany

Sue Williams

Born in Chicago Heights, Illinois, 1954
Lives in New York, New York
Studied at the Cooper Union for the Advancement of Science and
Art, New York (1973); California Institute of the Arts, Valencia
(BFA, 1976)

1997 "Birth of the Cool: American Painting from Georgia
 O'Keeffe to Christopher Wool," Deichtorhallen,
 Hamburg, Germany (traveling)

1996 Jean Bernier, Athens, Greece*
 Regen Projects, Los Angeles, California*
 303 Gallery, New York, New York*

1995 Galerie Metropol, Vienna, Austria*

Robert Wilson

Born in Waco, Texas, 1941
Lives in New York, New York
Studied at the University of Texas at Austin; Pratt Institute,
Brooklyn, New York (BFA, 1966)

1996 "Four Saints in Three Acts," Houston Grand
 Opera, Texas
 "Time Rocker," Thalia Theater, Hamburg, Germany

1995 "H.G.," 1995 Artangel/Beck's Commission, Clink
 Street Vaults, London, England
 "Persephone," Guild Hall, East Hampton, New York
 "Snow on the Mesa," Kennedy Center, Washington, D.C.

The Wooster Group

The Wooster Group is an ensemble of artists. Its core members
are Jim Clayburgh, Willem Dafoe, Spalding Gray, Elizabeth
LeCompte, Peyton Smith, Kate Valk, and Ron Vawter (1948–1994).
Since 1975, the Group, with its associates and staff, has created and
performed a large body of theater, video, and film work at the
group's permanent home, The Performing Garage in New York
City. The Group's works have toured in North and South America,
Europe, and Asia. Recent theater works include *House Lights*
(in progress) and *The Hairy Ape* (1995). Recent film and video
works include *Wrong Guys* (in progress).

Compiled by Jenelle Porter and Irene Tsatsos.

Works in the Exhibition*

Doug Aitken

Diamond Sea, 1997
Videotape, color, sound; 19 minutes
303 Gallery, New York

Roman Anikushin and Bob Paris

the birds, 1995
Videotape, color, sound; 2 minutes,
58 seconds
Collection of the artists

Michael Ashkin

No. 49, 1997
Flour, portland cement, and N-scale
models, 12 x 300 x 120 (30.5 x
762 x 304.8)
Bronwyn Keenan Gallery, New York

Robert Attanasio

Not from Concentrate, 1995
Soundtrack by Robert Attanasio and
Andrew Giannelli
Videotape, color, sound; 6 minutes
Collection of the artist

Burt Barr

Slow-Mo, 1996
Videotape, black-and-white, silent;
9 minutes, 48 seconds
Paula Cooper Gallery, New York

Zoe Beloff

Beyond, 1997
CD-Rom
Collection of the artist

Douglas Blau

Sacred Allegory, 1996
Mixed-media assemblage, 36 x 216
(91.4 x 548.6) overall
Collection of the artist

Louise Bourgeois

Torso, 1996
Fabric, 12 x 25 x 15 (30.5 x 63.5 x 38.1)
Collection of the artist

Arched Figure No. 1, 1997
Fabric, rubber, and steel, 9 x 20 x 6
1/2 (22.8 x 50.8 x 16.5)
Collection of the artist

Arched Figure No. 2, 1997
Fabric, bone, and steel,
12 x 9 1/2 x 33 (30.4 x 24.1 x 83.8)
Collection of the artist

Arched Figure No. 3, 1997
Fabric and steel, 20 x 14 x 49
(50.8 x 35.5 x 124.4)
Private collection; courtesy Cheim &
Read, New York

Foot, 1997
Fabric, 6 x 31 x 10 (15.2 x 78.7 x 25.4)
Collection of the artist

Untitled, 1997
Steel, fabric, bone, wood, glass,
and rubber, 120 x 72 x 48 (304.8 x
182.8 x 121.9)
Collection of the artist

Chris Burden

Pizza City, 1991-96
Toys and model buildings mounted on
tables, 25 tables, approximately
72 x 30 x 29 (182.9 x 76.2 x 73.7) each
MAK—Österreichisches Museum für
Angewandte Kunst, Vienna, Austria

Bureau of Inverse Technology

Suicide Box, 1996
Videotape, color, sound; 13 minutes
Blasthaus Gallery, San Francisco

Charles Burnett

The Glass Shield, 1995
35mm film, color, sound; 110 minutes
Miramax Films, New York

Vija Celmins

Night Sky #9, 1994-96
Oil on canvas, 38 x 47 (96.5 x 119.4)
Collection of the artist; courtesy
McKee Gallery, New York

Untitled #11, 1996
Charcoal on paper, 17 1/8 x 22
(43.5 x 55.9)
Collection of John Sacchi

Night Sky Series #14, 1997
Charcoal on paper, 17 1/2 x 22
(44.5 x 55.9)
McKee Gallery, New York

Night Sky Series #15, 1997
Charcoal on paper, 17 1/2 x 22
(44.5 x 55.9)
Collection of the artist; courtesy
McKee Gallery, New York

Abigail Child

B/side, 1996
16mm film, color, sound; 38 minutes
Collection of the artist

Francesco Clemente

Ardharinesvara, 1994-95
Pastel on paper, 26 x 19 (66 x 48.3)
Collection of the artist; courtesy
Gagosian Gallery, New York

Day and Night, 1994-95
Pastel on paper, 26 x 19 (66 x 48.3)
Collection of the artist; courtesy
Gagosian Gallery, New York

Knot, 1994-95
Pastel on paper, 26 x 19 (66 x 48.3)
Collection of the artist; courtesy
Gagosian Gallery, New York

Journey, 1994-95
Pastel on paper, 26 x 19 (66 x 48.3)
Collection of the artist; courtesy
Gagosian Gallery, New York

Musica da Camera, 1994-95
Pastel on paper, 26 x 19 (66 x 48.3)
Collection of the artist; courtesy
Gagosian Gallery, New York

Musica da Camera, 1994-95
Pastel on paper, 26 x 19 (66 x 48.3)
Collection of the artist; courtesy
Gagosian Gallery, New York

Musica da Camera, 1994-95
Pastel on paper, 26 x 19 (66 x 48.3)
Collection of the artist; courtesy
Gagosian Gallery, New York

Musica da Camera, 1994-95
Pastel on paper, 26 x 19 (66 x 48.3)
Collection of the artist; courtesy
Gagosian Gallery, New York

Musica da Camera, 1994-95
Pastel on paper, 26 x 19 (66 x 48.3)
Collection of the artist; courtesy
Gagosian Gallery, New York

Rose, 1994-95
Pastel on paper, 26 x 19 (66 x 48.3)
Collection of the artist; courtesy
Gagosian Gallery, New York

Semana Santa I, 1994-95
Pastel on paper, 26 x 19 (66 x 48.3)
Collection of the artist; courtesy
Gagosian Gallery, New York

Semana Santa II, 1994-95
Pastel on paper, 26 x 19 (66 x 48.3)
Collection of the artist; courtesy
Gagosian Gallery, New York

Semana Santa III, 1994-95
Pastel on paper, 26 x 19 (66 x 48.3)
Collection of the artist; courtesy
Gagosian Gallery, New York

Semana Santa IV, 1994-95
Pastel on paper, 26 x 19 (66 x 48.3)
Collection of the artist; courtesy
Gagosian Gallery, New York

Semana Santa V, 1994-95
Pastel on paper, 26 x 19 (66 x 48.3)
Collection of the artist; courtesy
Gagosian Gallery, New York

Semana Santa VI, 1994-95
Pastel on paper, 26 x 19 (66 x 48.3)
Collection of the artist; courtesy
Gagosian Gallery, New York

Semana Santa VII, 1994-95
Pastel on paper, 26 x 19 (66 x 48.3)
Collection of the artist; courtesy
Gagosian Gallery, New York

Story, 1994-95
Pastel on paper, 26 x 19 (66 x 48.3)
Collection of the artist; courtesy
Gagosian Gallery, New York

Bruce Conner

LOOKING FOR MUSHROOMS, 1959-96
Music by Terry Riley, "POPPY NOGOOD
AND THE PHANTOM BAND"
16mm film, color, sound; 14 minutes,
30 seconds
Canyon Cinema, San Francisco

INKBLOT DRAWING, March 17, 1995
Ink and graphite on paper, 19 x 21
(48.3 x 53.3)
Curt Marcus Gallery, New York,
and Paula Z. Kirkeby, Contemporary
Fine Art, Palo Alto, California

TYGER! TYGER!, June 30, 1995
Ink and graphite on paper, YES glue,
and collage, 14 7/8 x 21 3/4
(37.8 x 55.2)
Curt Marcus Gallery, New York,
and Paula Z. Kirkeby, Contemporary
Fine Art, Palo Alto, California

UNTITLED, March 20, 1996
Ink on paper, YES glue on ragboard,
and Krylon fixative, 27 5/8 x 24
(70.2 x 61)
Gallery Paule Anglim, San Francisco,
and Paula Z. Kirkeby, Contemporary
Fine Art, Palo Alto, California

UNTITLED, March 26, 1996
Ink on paper, YES glue, and silk, 36
7/16 x 17 1/4 (92.6 x 43.8)
Kohn Turner Gallery, Los Angeles,
and Paula Z. Kirkeby, Contemporary
Fine Art, Palo Alto, California

UNTITLED, June 15, 1996
Ink and graphite on paper, YES glue,
and silk, 35 7/8 x 17 1/2 (91.1 x 44.5)
Kohn Turner Gallery, Los Angeles,
and Paula Z. Kirkeby, Contemporary
Fine Art, Palo Alto, California

Bryan Crockett

Ignis fatuus, 1997
Epoxy resin, latex balloons, and cord,
120 x 156 x 192 (304.8 x 396.2 x 487.7)
Collection of the artist

Philip-Lorca diCorcia

Los Angeles, 1994, from the series
Streetwork, 1993–
Ektacolor print, edition of 15, 30 x 40
(76.2 x 101.6)
PaceWildensteinMacGill, New York

New York, 1993, from the series
Streetwork, 1993–
Ektacolor print, edition of 15, 30 x 40
(76.2 x 101.6)
PaceWildensteinMacGill, New York

Tokyo, 1994, from the series
Streetwork, 1993–
Ektacolor print, edition of 15, 30 x 40
(76.2 x 101.6)
PaceWildensteinMacGill, New York

London, 1995, from the series
Streetwork, 1993–
Ektacolor print, edition of 15, 30 x 40
(76.2 x 101.6)
PaceWildensteinMacGill, New York

London, 1995, from the series
Streetwork, 1993–
Ektacolor print, edition of 15, 30 x 40
(76.2 x 101.6)
PaceWildensteinMacGill, New York

Hong Kong, 1996, from the series
Streetwork, 1993–
Ektacolor print, edition of 15, 30 x 40
(76.2 x 101.6)
PaceWildensteinMacGill, New York

Cheryl Dunye

Watermelon Woman, 1996
35mm film, color and black-and-
white, sound; 90 minutes
First Run Features, New York

Sam Easterson

Blowout, 1995
Videotape, color, sound; 3 minutes,
25 seconds
Collection of the artist

Wendy Ewald

Denise Collins, "My little sister
and her dolls," Kentucky, 1978,
from the series Dreams, 1978–
Gelatin silver print, 7 x 7 (17.8 x 17.8)
James Danziger Gallery, New York

Allen Sheperd, "I dreamed
I killed my best friend, Ricky
Dixon," Kentucky, 1979,
from the series Dreams, 1978–
Gelatin silver print, 11 x 10
(27.9 x 25.4)
James Danziger Gallery, New York

Denise Dixon, "I am the girl with
the snake around her neck,"
Kentucky, 1979, from the series
Dreams, 1978–
Gelatin silver print, 11 x 14
(27.9 x 35.6)
James Danziger Gallery, New York

Denise Dixon, "Phillip and
Jamie are creatures from outer
space in their spaceship,"
Kentucky, 1979, from the series
Dreams, 1978–
Gelatin silver print, 11 x 14
(27.9 x 35.6)
James Danziger Gallery, New York

Ruby Cornett, "Self-portrait
in a dream about floating,"
Kentucky, 1979, from the series
Dreams, 1978–
Gelatin silver print, 8 x 10
(20.3 x 25.4)
James Danziger Gallery, New York

Denise Dixon, "My brother
the mud monster," Kentucky, 1980,
from the series Dreams, 1978–
Gelatin silver print, 11 x 14
(27.9 x 35.6)
James Danziger Gallery, New York

Johnny Wilder, Kentucky, 1981,
from the series Dreams, 1978–
Gelatin silver print, 16 x 20
(40.6 x 50.8)
James Danziger Gallery, New York

Carlos Andres Villanueva, "I
dreamed that my sister and the
pig were dead on the ground,"
Colombia, 1982, from the series
Dreams, 1978–
Gelatin silver print, 8 x 10
(20.3 x 25.4)
James Danziger Gallery, New York

Carlos Andres Villanueva, "My
sister is hiding behind the bench,
frightened of me," Colombia, 1982,
from the series Dreams, 1978–
Gelatin silver print, 8 x 10
(20.3 x 25.4)
James Danziger Gallery, New York

Dalida Reyes, "My first communion dress hanging on the wall," Colombia, 1982, from the series Dreams, 1978–
Gelatin silver print, 8 x 10 (20.3 x 25.4)
James Danziger Gallery, New York

Diamel Vargas, "A ghost fallen from fright," Colombia, 1983, from the series Dreams, 1978–
Gelatin silver print, 8 x 10 (20.3 x 25.4)
James Danziger Gallery, New York

Louise Arturo Gonzalez, "The sleepyhead," Colombia, 1983, from the series Dreams, 1978–
Gelatin silver print, 8 x 10 (20.3 x 25.4)
James Danziger Gallery, New York

Elvert Reyes, "The dead boy in the squatter settlement," Colombia, 1987, from the series Dreams, 1978–
Gelatin silver print, 8 x 10 (20.3 x 25.4)
James Danziger Gallery, New York

The two Janets learning to use the camera, Bogotá, Colombia, 1987, from the series Dreams, 1978–
Gelatin silver print, 11 x 14 (27.9 x 35.6)
James Danziger Gallery, New York

Baby's Funeral, Colombia, 1988, from the series Dreams, 1978–
Gelatin silver print, 16 x 20 (40.6 x 50.8)
James Danziger Gallery, New York

The mirror, Colombia, 1988, from the series Dreams, 1978–
Gelatin silver print, 16 x 20 (40.6 x 50.8)
James Danziger Gallery, New York

Chandu, "Hemat left his shoes behind when he went to worship the goddess Chamunda," India, 1989, from the series Dreams, 1978–
Gelatin silver print, 11 x 14 (27.9 x 35.6)
James Danziger Gallery, New York

Kalu Mohanji, "I dreamed Chandu's feet were going to crush me," India, Sadhu Harin, 1989, from the series Dreams, 1978–
Gelatin silver print, 8 x 10 (20.3 x 25.4)
James Danziger Gallery, New York

Kalu Mohanji, "My lame cousin-brother is dressed like a saint," India, 1989, from the series Dreams, 1978–
Gelatin silver print, 8 x 10 (20.3 x 25.4)
James Danziger Gallery, New York

Sajjan, "My cousin-sister's bride-groom," India, 1989, from the series Dreams, 1978–
Gelatin silver print, 11 x 14 (27.9 x 35.6)
James Danziger Gallery, New York

Samju looking at her negatives, India, 1989, from the series Dreams, 1978–
Gelatin silver print, 11 x 14 (27.9 x 35.6)
James Danziger Gallery, New York

Sarfu and his friend at the Salam Balak Trust School for street children, India, 1989, from the series Dreams, 1978–
Gelatin silver print, 16 x 20 (40.6 x 50.8)
James Danziger Gallery, New York

Javier Bautista, "The River Monsters," Chiapas, Mexico, 1991, from the series Dreams, 1978–
Gelatin silver print, 11 x 14 (27.9 x 35.6)
James Danziger Gallery, New York

Salvador Gòmez Jimènez, "My friends are picking flowers," Chiapas, Mexico, 1991, from the series Dreams, 1978–
Gelatin silver print, 16 x 20 (40.6 x 50.8)
James Danziger Gallery, New York

Sebastian Gòmez Hernàndez, "The devil is spying on the girls," Chiapas, Mexico, 1991, from the series Dreams, 1978–
Gelatin silver print, 16 x 20 (40.6 x 50.8)
James Danziger Gallery, New York

Sebastiàn Gòmez Jimènez, "The woman is robbing a hen," Chiapas, Mexico, 1991, from the series Dreams, 1978–
Gelatin silver print, 11 x 14 (27.9 x 35.6)
James Danziger Gallery, New York

Vladimir Stàlin Vargas, "The hens going into the kitchen," Chiapas, Mexico, 1991, from the series Dreams, 1978–
Gelatin silver print, 11 x 14 (27.9 x 35.6)
James Danziger Gallery, New York

Anthony Kinnear, "Neighbors in the yard," South Africa, 1992, from the series Dreams, 1978–
Gelatin silver print, 16 x 20 (40.6 x 50.8)
James Danziger Gallery, New York

Natasha Prinsloo, "A dream of my sister and the baby," South Africa, 1992, from the series Dreams, 1978–
Gelatin silver print, 11 x 14 (27.9 x 35.6)
James Danziger Gallery, New York

Ilias Ben Azzouz, "The meat of the sheep," Morocco, 1995, from the series Dreams, 1978–
Gelatin silver print, 16 x 20 (40.6 x 50.8)
James Danziger Gallery, New York

Mohamed Bencharki, "Untitled," Morocco, 1995, from the series Dreams, 1978–
Gelatin silver print, 11 x 14 (27.9 x 35.6)
James Danziger Gallery, New York

Rajae Jabine, "My little sister," Hafsa, Morocco, 1995, from the series Dreams, 1978–
Gelatin silver print, 16 x 20 (40.6 x 50.8)
James Danziger Gallery, New York

William Forsythe

Solo, 1995
Thomas Balogh, director; Jess Hall, director of photography
Videotape, black-and-white, sound; 7 minutes
RD Studio Productions, Paris

Leah Gilliam

Sapphire and the Slave Girl, 1995
Videotape, black-and-white, sound; 17 minutes
Collection of the artist; distributed by Third World Newsreel, New York

Michael Gitlin

Berenice, 1996
16mm film with optical soundtrack, color; 51 minutes
Collection of the artist

Felix Gonzalez-Torres

Untitled (America), 1994-95
42 fifteen-watt bulbs, extension cords, rubber light sockets, dimensions vary
Whitney Museum of American Art; Purchase, with funds from the Contemporary Painting and Sculpture Committee 96.74a-1

Dan Graham

New Space Showing Videos, 1995
Two-way mirror glass, clear tempered
glass, and mahogany, 84 x 348 x 168
(213.4 x 883.9 x 426.7)
Viewing stations 1–3 (video programs
selected by the artist)
1) **Architecture**: includes recent
projects by Itsuko Hasegawa, Herzog
& De Meuron, and Dan Graham
2) **Music**: includes John Caruccio and
Rio "Rocket" Valledor's **Battle
Stations**; selection of contemporary
alternative-rock-music videos
including Robert Frank/Patti Smith,
Sadie Benning/Come, Kim Gordon and
Spike Jonze/The Breeders, and more
3) **Cartoons**: contemporary interna-
tional selections
Viewing station 4: Zoe Beloff's
Beyond, 1997, CD-Rom
Listening station 5: Selected pro-
grams by SoundLab and Negativland
Marian Goodman Gallery, New York

David Hammons

Phat Free 1995-97
Cinematography by Alex Harsley
Videotape, color, sound; 7 minutes
Collection of the artist

Ken Jacobs

The Georgetown Loop, 1995
35mm film, black-and-white, silent;
10 minutes
Collection of the artist

Ilya Kabakov

Treatment with Memories, 1997
Mixed-media installation,
approximately 144 x 636 x 288 (365.8
x 1615.4 x 731.5)
Barbara Gladstone Gallery, New York

Martin Kersels

Whitney Lobby Composition, 1997
Music by Mark Wheaton
Sound broadcast installation, mixed
media, dimensions vary
Dan Bernier Gallery, Santa Monica,
and Jay Gorney Modern Art, New York

Annette Lawrence

**The Ancestors and the
Womb, II**, 1995
Paper, acrylic, and graphite
on plywood, 48 x 36 (121.9 x 91.4)
Gerald Peters Gallery, Dallas

**The Ancestors and the
Womb, IV**, 1995
Paper, acrylic, and graphite
on plywood, 48 x 36 (121.9 x 91.4)
Gerald Peters Gallery, Dallas

**The Ancestors and the
Womb, V**, 1995
Paper, acrylic, and graphite
on plywood, 48 x 36 (121.9 x 91.4)
Gerald Peters Gallery, Dallas

Moons, 1996
Mixed media on paper, 13 sheets,
15 x 10 (38.1 x 25.4) each
Gerald Peters Gallery, Dallas

Iara Lee

Synthetic Pleasures, 1996
35mm film, color, sound; 83 minutes
Caipirinha Productions, New York

Charles Long and Stereolab

Bubble Gum Station, from
The Amorphous Body Study Center
(exhibition copy), 1995
Modeling clay, sound equipment, and
furniture, 91 x 60 (231.1 x 152.4)
diameter
Collection of Susan and Lewis
Manilow; courtesy Tanya Bonakdar
Gallery, New York

Buloop, Buloop, from
**The Amorphous Body Study
Center**, 1995
Rubber, sound equipment, and water
cooler; water cooler: 53 x 12 1/2 x 13
1/2 (134.6 x 31.8 x 34.3)
Tanya Bonakdar Gallery, New York

Zoe Leonard

The Fae Richards Photo Archive,
1993-96
Created for Cheryl Dunye's film
Watermelon Woman, 1996
78 black-and-white and 4 color
photographs, 3 3/8 x 3 3/8 to 13 7/8 x
9 7/8 (8.6 x 8.6 to 35.2 x 25.1),
edition of 3; notebook of seven pages
of typescript on paper: 11 1/2 x 9
(29.2 x 22.9)
Paula Cooper Gallery, New York

Sharon Lockhart

Untitled, 1996
C-print, edition of 6, 32 x 43
(81.3 x 109.2)
Collection of Andrew Ong

Untitled, 1996
C-print, edition of 6, 49 x 61 1/8
(124.5 x 155.3)
Whitney Museum of American Art,
New York; Promised gift of Mrs. Melva
Bucksbaum

Untitled, 1997
C-print, edition of 6, 49 x 65
(124.5 x 165.1)
Friedrich Petzel Gallery, New York, and
Blum & Poe Gallery, Los Angeles

3 to 1 in Groovy Green, from
**The Amorphous Body Study
Center**, 1995
Lacquer on plastic, compact disc,
compact disc player, headphones,
wooden table, and wooden sofa
with fabric cushions, dimensions vary
Walker Art Center, Minneapolis;
McKnight Acquisition Fund

Kristin Lucas

Cable Xcess, 1996
Videotape, color, sound; 4 minutes,
48 seconds
Collection of the artist

Host, 1997
Videotape, color, sound; 7 minutes,
36 seconds
Collection of the artist

Paul McCarthy

Untitled, 1997
Mixed-media installation,
approximately 156 x 276 x 444
(396.2 x 701 x 1127.8)
Luhring Augustine, New York

Kerry James Marshall

Our Town, 1995
Acrylic and collage on canvas,
100 x 144 (254 x 365.8)
Jack Shainman Gallery, New York

Watts 1963, 1995
Acrylic and collage on canvas,
114 x 135 (290 x 343)
The Saint Louis Art Museum, Missouri;
Minority Artists Purchase Fund

Pastime, 1997
Acrylic and collage on canvas banner,
108 x 162 (274.3 x 411.5)
Collection of the artist

Antonio Martorell

Unlaced Atlas/Mundillo Desencajado I (Europe), 1996
Cotton thread, approximately 60 x 84 (152.4 x 213.4)
Interpreted and fabricated by the Borinquen Lacers, San Juan, Puerto Rico
Collection of the artist; courtesy Compañia de Turismo de Puerto Rico

Unlaced Atlas/Mundillo Desencajado Pattern I (Europe), 1996
Graphite on paper, approximately 60 x 84 (152.4 x 213.4)
Fabricated from an original drawing by Giovanni Rodriguez
Collection of the artist

Unlaced Atlas/Mundillo Desencajado II (The Caribbean), 1996
Cotton thread, approximately 60 x 84 (152.4 x 213.4)
Interpreted and fabricated by the Borinquen Lacers, San Juan, Puerto Rico
Collection of the artist; courtesy Compañia de Turismo de Puerto Rico

Unlaced Atlas/Mundillo Desencajado Pattern II (The Caribbean), 1996
Graphite on paper, approximately 60 x 84 (152.4 x 213.4)
Fabricated from an original drawing by Giovanni Rodriguez
Collection of the artist

Paul D. Miller

Zona Rosa, 1996
Original soundtrack
Collection of the artist

Christopher Münch

Color of a Brisk and Leaping Day, 1996
35mm film, black-and-white, sound; 87 minutes
Artistic License Releasing, New York

Bruce Nauman

End of the World, 1996, with Lloyd Maines
Video projectors, and laserdiscs, dimensions vary
Private collection

Gabriel Orozco

My Hand Is My Heart, 1991
Terracotta, 6 x 4 x 6 (15.2 x 10.2 x 15.2)
Marian Goodman Gallery, New York

Model (Clay Box), 1992
Clay box, 1 1/2 x 6 x 5 (3.8 x 15.2 x 12.7)
Marian Goodman Gallery, New York

Model (Frozen Drops), 1992
Cotton and Plasticine, 2 1/2 x 7 1/2 x 8 (6.4 x 19.1 x 20.3)
Marian Goodman Gallery, New York

Model (Nest), 1992
Cotton and Plasticine, 1 x 6 1/4 x 6 7/8 (2.5 x 15.9 x 17.5)
Marian Goodman Gallery, New York

Model (Skin Stones), 1992
Plasticine, lemons, and plastic, 15 parts, 2 1/2 x 11 x 10 (6.4 x 27.9 x 25.4)
Marian Goodman Gallery, New York

Model (Tortilla Spitting), 1992
Papier-mâché, 2 1/2 x 8 x 8 (6.4 x 20.3 x 20.3)
Marian Goodman Gallery, New York

Model (Two Yielding Stones), 1992
Plasticine, 3 1/4 x 9 x 5 (8.3 x 22.9 x 12.7)
Marian Goodman Gallery, New York

Model (Converse Box), 1993
Cardboard box, 4 1/4 x 13 1/4 x 5 3/8 (10.8 x 33.7 x 13.6)
Marian Goodman Gallery, New York

Model (DS Model), 1993
Plastic model, 3 1/4 x 12 x 3 1/2 (8.3 x 30.5 x 8.9)
Marian Goodman Gallery, New York

Model (Four Boxes), 1993
Cardboard and Plasticine, 1 3/4 x 10 x 13 (4.4 x 25.4 x 33)
Marian Goodman Gallery, New York

Model (Growing Stone), 1993
Plasticine, 5 x 7 x 7 (12.7 x 17.8 x 17.8)
Marian Goodman Gallery, New York

Model (½ Moon), 1993
Papier-mâché, 1/2 x 3 x 3 1/4 (1.3 x 7.6 x 8.3)
Marian Goodman Gallery, New York

Model (Lemons & Oranges), 1993
Plasticine, and lemon and orange peels, 5 parts, 3 1/4 x 9 x 12 (8.3 x 22.9 x 30.5)
Marian Goodman Gallery

Model (Recipes), 1993
Plastic coffee cup and Plasticine, 2 1/2 x 7 x 7 (6.4 x 17.8 x 17.8)
Marian Goodman Gallery, New York

Model (Tea pot), 1993
Porcelain, 3 parts, 2 1/2 x 9 1/2 x 8 (6.4 x 24.1 x 20.3)
Marian Goodman Gallery, New York

Soft Blue (Suave azul), 1993
Letraset and Plasticine, edition of 3, 4 1/2 x 4 1/2 x 4 1/2 (11.4 x 11.4 x 11.4)
Marian Goodman Gallery, New York

Traffic Worm, 1993-95
Cibachrome, edition of 5, 16 x 20 (40.6 x 50.8)
Marian Goodman Gallery, New York

Model (Clear Seed), 1994
Mixed media, seed pods, and plastic, 6 x 8 1/2 x 7 (15.2 x 21.6 x 17.8)
Marian Goodman Gallery, New York

Model (Lunar Lander), 1994
Plastic model, 3 1/2 x 10 1/4 x 3 1/2 (8.9 x 26 x 8.9)
Marian Goodman Gallery, New York

Model (Onion Crown), 1994
Onion skin and Plasticine, 3 x 3 x 2 (7.6 x 7.6 x 5.1)
Marian Goodman Gallery, New York

Model (White Container), 1994
Styrofoam and Plasticine, 2 3/4 x 9 1/4 x 5 3/8 (7 x 23.5 x 13.7)
Marian Goodman Gallery, New York

Big Bang, 1995
Cibachrome, edition of 5, 16 x 20 (40.6 x 50.8)
Marian Goodman Gallery, New York

Comedor en Tepoztlán, 1995
Cibachrome, edition of 5, 16 x 20 (40.6 x 50.8)
Marian Goodman Gallery, New York

Dog Circle, 1995
Cibachrome, edition of 5, 16 x 20 (40.6 x 50.8)
Marian Goodman Gallery, New York

Green Ball, 1995
Cibachrome, edition of 5, 16 x 20 (40.6 x 50.8)
Marian Goodman Gallery, New York

Hose (Manguera Dormida), 1995
Cibachrome, edition of 5, 16 x 20 (40.6 x 50.8)
Marian Goodman Gallery, New York

Model (After the Hole), 1995
Aluminum, 2 1/2 x 4 x 4 (6.4 x 10.2 x 10.2)
Marian Goodman Gallery, New York

Sheep and Tires, 1995
Cibachrome, edition of 5, 16 x 20 (40.6 x 50.8)
Marian Goodman Gallery, New York

Blue Sandals, 1996
Cibachrome, edition of 5, 16 x 20 (40.6 x 50.8)
Marian Goodman Gallery, New York

Common Dream, 1996
Cibachrome, edition of 5, 16 x 20
(40.6 x 50.8)
Marian Goodman Gallery, New York

Parachute in Iceland, 1996
Cibachrome, edition of 5, 16 x 20
(40.6 x 50.8)
Marian Goodman Gallery, New York

Tree Bench, 1996
Cibachrome, edition of 5, 16 x 20
(40.6 x 50.8)
Marian Goodman Gallery, New York

Vindu's Ladder, 1996
Cibachrome, edition of 5, 20 x 16
(50.8 x 40.6)
Marian Goodman Gallery, New York

Tony Oursler

Mansheshe, 1997
Ceramic, glass, video player,
videocassette, CPJ 200 video
projector, and sound, approximately
11 x 7 x 8 (27.9 x 17.8 x 20.3) each
Metro Pictures, New York

Laura Parnes

Ladies, There's a Space You Can't
Go, 1995
Videotape, color, sound; 6 minutes
Collection of the artist

Jennifer Pastor

The Four Seasons: Untitled (Fall),
1994-96
Copper, plastic, polyurethane paint,
and oil paint, 120 x 78 x 57
(304.8 x 198.1 x 144.8)
Collection of Eileen and Peter Norton

The Four Seasons: Untitled
(Spring), 1994-96
High-density polyurethane foam,
brass, hair, and paint, 6 x 4
(15.2 x 10.2)
Collection of Eileen and Peter Norton

The Four Seasons: Untitled
(Summer), 1994-96
Fiberglass, enamel paint, and oil
paint, 3 parts: 24 x 21 x 6 (61 x 53.3 x
15.2); 19 x 19 x 32 (48.3 x 48.3 x 81.3);
and 33 x 29 x 24 (83.8 x 73.7 x 61)
Collection of Eileen and Peter Norton

The Four Seasons: Untitled
(Winter), 1994-96
Wood, pipe cleaners, granulated turf,
polyurethane foam, and cotton
flocking, 28 x 78 x 59 (71.1 x 198.1 x
149.9)
Collection of Eileen and Peter Norton

Raymond Pettibon

Project for the facade of the
Whitney Museum

Richard Phillips

Horizontal Blonde, 1996
Oil on linen, 59 x 83 (149.9 x 210.8)
Collection of Howard E. Rachofsky

Peel, 1996
Oil on linen, 78 x 86 1/4 (198.1 x 219.1)
Dr. Richard and Mrs. Daria Feinstein

Alien, 1996-97
Oil on linen, 84 x 61 (213.4 x 154.9)
Collection of John and Dede Brough

Shaking, 1996-97
Oil on linen, 78 x 95 (198.1 x 241.3)
Private collection; courtesy of
Turner & Runyon Gallery, Dallas

Lari Pittman

Once Awkward, Now Spacious and
Elastic, 1996
Oil on prepared wood with attached
framed work on paper, 60 x 48
(152.4 x 121.9)
Collection of Mr. and Mrs. Milton Fine

Once Inverted, Now Throw-Away
and Exponential, 1996
Oil on prepared wood with attached
framed work on paper, 60 x 48
(152.4 x 121.9)
Private collection; courtesy
Jay Jopling White Cube, London, and
Regen Projects, Los Angeles

Once Left for Dead, Now Madly
Kissed, 1996
Oil on prepared wood with attached
framed work on paper, 60 x 48
(152.4 x 121.9)
Collection of Barbara Goldfarb

Once Pastoral and Deceptive, Now
Congested and Pragmatic, 1997
Oil on prepared wood with attached
framed work on paper, 60 x 48
(152.4 x 121.9)
Private collection; courtesy
Jay Gorney Modern Art, New York, and
Regen Projects, Los Angeles

Once Religious and Descriptive,
Now Secular and Fragrant, 1997
Oil on prepared wood with attached
framed work on paper, 60 x 48
(152.4 x 121.9)
Private collection; courtesy Regen
Projects, Los Angeles, and
Jay Gorney Modern Art, New York

Richard Prince

My Best, 1996
Acrylic, silkscreen, and oilstick on
canvas, 63 x 48 (160 x 121.9)
Barbara Gladstone Gallery, New York

Pretty Good, 1996
Acrylic, silkscreen, and oilstick on
canvas, 65 x 48 (165.1 x 121.9)
Barbara Gladstone Gallery, New York

So Much, 1996
Acrylic, silkscreen, and oilstick on
canvas, 63 x 48 (160 x 121.9)
Barbara Gladstone Gallery, New York

Charles Ray

Self-Portrait with Homemade
Clothes, 1997
35mm film; 4 minutes
Collection of the artist

Jason Rhoades

Uno Momento/theatre in my
dick/a look to the
physical/ephemeral, 1996
Mixed-media installation, 300 x 840
(762 x 2133.6) approximately
Collection of Hauser & Wirth

Matthew Ritchie

Seven Earths, 1995
Oil and marker on canvas, 60 x 84
(152.4 x 213.4)
Basilico Fine Arts, New York

The Binding Problem, 1996
Oil and marker on canvas, 86 x 100
(218.4 x 254)
Robert J. Shiffler Collection and
Archive

The Hard Way, 1996
Website
http://www.adaweb.com/adaweb/
influx/hardway/

Autogenesis, 1996-97
Ink and graphite on mylar, 21
drawings, 11 x 8 1/2 (27.9 x 21.6) each
Basilico Fine Arts, New York

Time Novel, 1997
Oil and marker on canvas, 100 x 160
(254 x 406.4)
Basilico Fine Arts, New York

Aaron Rose

Untitled (The Untergrowth
Series), 1994-96
Unique gold and silver prints, 11 x 14
(27.9 x 35.6)
Daniel Wolf, New York

Untitled (The Untergrowth
Series), 1994-96
Unique gold and silver prints, 11 x 14
(27.9 x 35.6)
Daniel Wolf, New York

Untitled (The Untergrowth
Series), 1994-96
Unique gold and silver prints, 11 x 14
(27.9 x 35.6)
Daniel Wolf, New York

Untitled (The Untergrowth
Series), 1994-96
Unique gold and silver prints, 11 x 14
(27.9 x 35.6)
Daniel Wolf, New York

Untitled (The Untergrowth
Series), 1994-96
Unique gold and silver prints, 11 x 14
(27.9 x 35.6)
Daniel Wolf, New York

Untitled (The Untergrowth
Series), 1994-96
Unique gold and silver prints, 11 x 14
(27.9 x 35.6)
Daniel Wolf, New York

Untitled (The Untergrowth
Series), 1994-96
Unique gold and silver prints, 11 x 14
(27.9 x 35.6)
Daniel Wolf, New York

Edward Ruscha

Brave Man's Porch, 1996
Acrylic on canvas, 82 x 50
(208.3 x 127)
Collection of Anthony d'Offay Gallery,
London

Bloated Empire, 1997
Acrylic on canvas, 77 1/2 x 77 1/2
(196.8 x 196.8)
Collection of the artist

Industrial Truck Bodies, 1997
Acrylic on canvas, 42 x 84
(106.7 x 213.4)
Collection of the artist

John Schabel

Untitled (Passenger #2), 1994-95
Toned gelatin silver print, edition of
10, 23 1/4 x 19 1/4 (59.1 x 48.9)
Collection of Frances and John
Bowes; courtesy Dan Bernier Gallery,
Santa Monica

Untitled (Passenger #3), 1994-95
Toned gelatin silver print,
edition of 10, 23 1/4 x 19 1/4 (59.1 x 48.9)
The Buhl Collection, New York;
courtesy Morris Healy Gallery,
New York

Untitled (Passenger #4), 1995
Toned gelatin silver print,
edition of 10, 23 1/4 x 19 1/4 (59.1 x 48.9)
Collection of Zwi Wasserstein;
courtesy Morris Healy Gallery,
New York

Untitled (Passenger #7), 1995
Toned gelatin silver print, edition of
10, 23 1/4 x 19 1/4 (59.1 x 48.9)
Metropolitan Savings Bank,
Cleveland; courtesy Morris Healy
Gallery, New York

Untitled (Passenger #9), 1995
Toned gelatin silver print, edition of
10, 23 1/4 x 19 1/4 (59.1 x 48.9)
Metropolitan Savings Bank,
Cleveland; courtesy Morris Healy
Gallery, New York

Untitled (Passenger #11), 1995
Toned gelatin silver print, edition of
10, 23 1/4 x 19 1/4 (59.1 x 48.9)
The Emily and Jerry Spiegel Family
Collection; courtesy Morris Healy
Gallery, New York

Katy Schimert

The Moon, 1995
Aluminum screen, 144 x 96 x 6 (365.8
x 243.8 x 15.2)
Collection of Susan and Michael Hort

Oedipus Rex, 1996
Ink and Plasticine on paper, 11 x 17
(27.9 x 43.2)
Collection of David Zwirner

Untitled, 1996
Watercolor, Plasticine, and aluminum
tape on paper, 13 x 20 (33 x 50.8)
Collection of Iwan Wirth and Manuela
Hauser-Wirth

The Five Senses, 1997
Ceramic with terra sigillatta, dimen-
sions variable
David Zwirner Gallery, New York, and
AC Project Room, New York

The Oedipal Blind Spot, 1997
Aluminum foil tape, thread, push
pins, and graphite, approximately
120 x 192 x 7 (304.8 x 487.7 x 17.8)
David Zwirner Gallery, New York, and
AC Project Room, New York

Glen Seator

Untitled, 1997
Wood, steel, sheetrock, glass,
electrical fittings, carpet, and paint,
approximately 108 x 192 x 216
(274.3 x 487.7 x 548.6)
Collection of the artist

Paul Shambroom

Untitled (Combat Alert Facility
for bomber crews, Ellsworth
Air Force Base, South Dakota),
1992, from the series Nuclear
Weapons, 1990-95
Color coupler print, 48 x 61
(121.9 x 152.4)
Walker Art Center, Minneapolis;
Clinton and Della Walker Acquisition
Fund

Untitled (Minuteman II missile in
truck, technician preparing for
transport in Transporter Erector
vehicle, Ellsworth Air Force
Base, South Dakota, 1992, from the
series Nuclear Weapons, 1990-95
Color coupler print, 48 x 61
(121.9 x 152.4)
Walker Art Center, Minneapolis;
Clinton and Della Walker Acquisition
Fund

Untitled (Peacekeeper missile
W87/Mk-21 Reentry vehicle
[warhead] storage, each with 300
kiloton estimated yield, F.E.
Warren Air Force Base, Wyoming),
1992, from the series Nuclear
Weapons, 1990-95
Color coupler print, 48 x 61
(121.9 x 152.4)
Collection of the artist

Untitled (B83 nuclear gravity
bombs, each with estimated
1 megaton yield, Barksdale Air
Force Base, Louisiana, 1995,
from the series Nuclear Weapons,
1990-95
Color coupler print, 39 x 48
(101.6 x 121.9)
Collection of the artist

David Sherman

Tuning the Sleeping Machine, 1996
16mm film, color, sound; 13 minutes
Canyon Cinema, San Francisco

Shahzia Sikander

Apparatus of Power, 1995
Vegetable pigment, dry pigment,
watercolor, and tea water
on wasli handmade paper, 9 x 6
(22.9 x 15.2)
Collection of Carol S. Craford

Separate Working Things, 1995
Vegetable pigment, dry pigment,
watercolor, and tea water on
wasli handmade paper, 9 1/2 x 6 1/2
(24.1 x 16.5)
Collection of Vishakha N. Desai

Uprooted, 1995
Vegetable pigment, dry pigment, and
watercolor on wasli handmade
paper, 8 1/2 x 7 1/4 (21.6 x 18.4)
Collection of Aliya Hasan

Whose Veiled Anyway?, 1997
Vegetable pigment, dry pigment,
watercolor, and tea water on wasli
handmade paper, 11 x 14 (27.9 x 35.6)
Hosfelt Gallery, San Francisco,
and Barbara Davis Gallery, Houston

Eye-I-ing Those Armorial
Bearings, 1997
Vegetable pigment, dry pigment,
watercolor, and tea water on
wasli handmade paper, 8 3/4 x 6
(22.2 x 15.2)
Hosfelt Gallery, San Francisco,
and Barbara Davis Gallery, Houston

Let It Ride, 1997
Vegetable pigment, dry pigment,
watercolor, tea, and gold wash
on wasli handmade paper, 13 x 9 1/2
(33 x 24.1)
Hosfelt Gallery, San Francisco,
and Barbara Davis Gallery, Houston

Perilous Order, 1997
Vegetable pigment, dry pigment,
watercolor, and tea water on
wasli handmade paper, 10 1/2 x 8
(26.7 x 20.3)
Hosfelt Gallery, San Francisco,
and Barbara Davis Gallery, Houston

Ready to Leave?, 1997
Vegetable pigment, dry pigment,
watercolor, and oil on wasli handmade
paper, 9 3/4 x 7 1/2 (24.8 x 19.1)
Hosfelt Gallery, San Francisco,
and Barbara Davis Gallery, Houston

Reinventing the Disclocation, 1997
Vegetable pigment, dry pigment,
watercolor, and tea and gold wash on
wasli handmade paper, 13 x 9 1/2
(33 x 24.1)
Hosfelt Gallery, San Francisco,
and Barbara Davis Gallery, Houston

Shashwati Talukdar

My Life as a Poster, 1995
16mm film, color, sound; 7 minutes,
30 seconds
National Asian American
Telecommunications
Association/Crosscurrent Media, San
Francisco

Diana Thater

Electric Mind, 1996
Videotape, video projectors, video
monitors, laserdisc players,
sync generator, and laserdiscs,
dimensions vary
Collection of the artist; courtesy
David Zwirner Gallery, New York, and
Brian Butler, Santa Monica

Cecilia Vicuña

A Net of Holes, 1997
Cotton thread installation, dimen-
sions vary
Collection of the artist

Kara Walker

Presenting Negro Scenes Drawn
Upon My Passage Through
the South and Reconfigured
for the Benefit of Enlightened
Audiences Wherever Such
May Be Found, By Myself, Missus
K.E.B. Walker, Colored, 1997
Cut paper and adhesive,
approximately 144 x 360 (365.8 x
914.4) overall
Collection of Susan and Lewis
Manilow

T.J. Wilcox

The Escape (of Marie
Antoinette), 1996
16mm film, color, sound; 12 minutes
Gavin Brown's Enterprise, New York

Sue Williams

Dot, 1996
Oil and acrylic on canvas, 72 x 84
(182.9 x 213.4)
303 Gallery, New York

Large Blue Gold and Itchy, 1996
Oil and acrylic on canvas, 96 x 108
(243.8 x 274.3)
303 Gallery, New York

Robert Wilson

La Mort de Molière, 1995
Videotape, color, sound; 47 minutes
INA, Paris

The Wooster Group

Wrong Guys, 1997
Videotape and 35mm film, color and
black-and-white, sound; 42 minutes
Collection of the artists

Performance

Cultural Alchemy

SoundLab, 1995–
Illbient happening
Live and electronic sound mix,
recorded video projection, instant
video feedback, and mixed media

William Forsythe

Solo, 1995
Choreography, approximately
12 minutes
Performed by William Forsythe
Music by Thom Willems; performed by
Maxim Franke

Amanda Miller

Paralipomena, 1996
Choreography, approximately
15 minutes
Performed by Amanda Miller and
Seth Tillett
Set design by Seth Tillett
Music by Giacinto Scelsi, excerpt
from Fleuve Magique

Tony Oursler, Constance DeJong, and Stephen Vitiello

Pink, 1997
Performance incorporating spoken
texts, original songs, and
images from CD-Rom, approximately
60 minutes
In Pink, DeJong operates interactive
digital visuals from a computer
station, narrating spoken texts and
songs. Her performance is also
staged to video projections, a tightly
scripted interaction of live and
prerecorded material, including a
camera appearance by Oursler
and DeJong in duet with an Oursler
video-doll. Pink is set to original
music by Vitiello, who plays live and
prerecorded scores from a sound-
station on stage.

National Committee

Mr. and Mrs. Anthony Ames
Atlanta, Georgia

Mr. and Mrs. H. Brewster Atwater, Jr.
Wayzata, Minnesota

Mr. and Mrs. Charles Balbach
Buffalo, New York

Mr. and Mrs. Sydney F. Biddle
New York, New York

Mrs. Melva Bucksbaum
Des Moines, Iowa

Mr. and Mrs. Paul Cassiday
Honolulu, Hawaii

The Honorable Anne Cox Chambers
Atlanta, Georgia

Mr. and Mrs. Paul Chambers
Trumansburg, New York

Mr. and Mrs. Thomas B. Coleman
New Orleans, Louisiana

Dr. and Mrs. David R. Davis
Medina, Washington

Mr. and Mrs. Peter H. Dominick, Jr.
Denver, Colorado

Mr. Stefan Edlis and Ms. Gail Neeson
Chicago, Illinois

Mr. and Mrs. Drew Gibson
Palo Alto, California

Mr. and Mrs. Brendan Gill
Bronxville, New York

Mr. and Mrs. Bernard A. Greenberg
Beverly Hills, California

Mr. and Mrs. R. Crosby Kemper
Kansas City, Missouri

Mr. and Mrs. Leonard A. Lauder
New York, New York

Mr. and Mrs. Gilbert C. Maurer
New York, New York

Mr. Byron R. Meyer
San Francisco, California

Mr. and Mrs. Robert E. Meyerhoff
Phoenix, Maryland

Mr. and Mrs. Nicholas Millhouse
New York, New York

Mrs. Louis S. Myers
Akron, Ohio

Mr. and Mrs. William Obering
Wilson, Wyoming

Mr. B. Waring Partridge III and Ms. Julia Jitkoff Partridge
Far Hills, New Jersey

Mr. and Mrs. James R. Patton, Jr.
Washington, D.C.

Mr. and Mrs. H. Charles Price
Dallas, Texas

Mr. and Mrs. Harold C. Price
Laguna Beach, California

Mrs. C. Lawson Reed
Cincinnati, Ohio

Mr. and Mrs. Leopoldo Rodes
Barcelona, Spain

Mr. and Mrs. Paul C. Schorr III
Lincoln, Nebraska

Mrs. Donald Scutchfield
Woodside, California

The Reverend and Mrs. Alfred R. Shands III
Crestwood, Kentucky

Mr. and Mrs. Robert Sosnick
Bloomfield Hills, Michigan

Dr. and Mrs. Norman Stone
San Francisco, California

Ms. Marion Stroud
Elverson, Pennsylvania

Mrs. Nellie Taft
Boston, Massachusetts

Mrs. Laila Twigg-Smith
Honolulu, Hawaii

Mr. and Mrs. Thurston Twigg-Smith
Honolulu, Hawaii

Mrs. Paul L. Wattis
San Francisco, California

Mrs. Cornelius Vanderbilt Whitney
Saratoga Springs, New York

Mr. and Mrs. David M. Winton
Wayzata, Minnesota

Mr. and Mrs. Robert Woods
Los Angeles, California

Officers and Trustees

Acknowledgments

Conceiving and realizing a Biennial Exhibition is one of the most rewarding and grueling experiences in the museum world. The ambitions are great, the expectations many and varied, the pressures of time and organization extreme, and there are contingencies at every turn. A good team is vital and we are fortunate to have one of the best. First of all, we must thank the Whitney's director, David A. Ross, for his passionate engagement with our ideas, his encouragement, and his insightful responses. Jenelle Porter, senior curatorial assistant, brought unflagging energy and an intense dedication to the project. During the past two years, she has handled many of the organizational details of the exhibition and catalogue with great spirit and diligence. Irene Tsatsos, exhibition coordinator, has approached the many challenges of this complex installation with persistence, diplomacy, and indefatigable concentration. We would also like to acknowledge Matthew Yokobosky, assistant curator, film and video, and his assistant, Glenn Phillips, for their advice and expertise in planning the film and video program and installations.

Our particular curatorial framework would have been difficult to sustain without the active endorsement of *Parkett* magazine, both in Zurich and New York. We would like to thank Bice Curiger, Jacqueline Burckhardt, Dieter von Graffenried, Frances Richard, Yvette Brackman, and Susanne Schmidt of the *Parkett* team for enthusiastically supporting their colleague during all stages of the project.

A project of this magnitude and ambition would be impossible to achieve without the additional support of private and public organizations. We would like to express our deep appreciation to Anthony Fawcett and Beck's for giving us the vote of confidence in their first major sponsoring venture in New York, and to Peter Fleissig for making the initial connection; to Dr. Joachim Sartorius, general director of the Goethe Institut; Dr. Stephan Nobbe, director, and Judith Maiworm, performance progam director, of Goethe Haus in New York; and The Wooster Group for making the performance program possible.

The process of organizing this exhibition was an adventure that took us to more than twenty cities, in the US and abroad, to research work by American artists. All along the way, we solicited the recommendations of an extensive network of people. Some were advisers who made formal presentations and compiled lists of artists for us to consider: Elizabeth Armstrong, Yvette Brackman, Bonnie Clearwater, Dana Friis-Hansen, Thelma Golden, Karen Indeck, Kyong Park, Ralph Rugoff, Daniela Salvioni, and Matthew Yokobosky. In film, video, sound, and new media we sought the advice of colleagues who specialize in these fields: Craig Baldwin, Graham Legatt, Marian Massone, Tony Oursler, and Benjamin Weil.

Others made less formal but very valuable suggestions: Chris Bruce, Shaun Caley, Dan Cameron, May Castleberry, Molly Davies, Sean Elwood, Leon Falk, Peter Fleissig, Richard Flood, Kim Gordon and Thurston Moore, Claudia Gould, Louis Grachos, Dave Hickey, Paul D. Miller, Herbert Muschamp, Peter Pakesch, Bob Reilly, Lane Relyea, Larry Rinder, Eugenie Tsai, Mark van de Walle, Neville Wakefield, and Catherine de Zegher.

Then there are those few individuals who provided their perceptions and personal support during the last eighteen months: Diego Cortez, Leon Falk, Walter Keller, Juan Muñoz, and Geoff Lowe and Constructed World.

We would like to thank everyone we have mentioned above for being so generous with their time. They have all contributed significantly to the life and vibrancy of this project.

During our odyssey in the US, Europe, and Brazil, we enjoyed the hospitality of many individuals and organizations. We are indebted to the National Committee of the Whitney Museum for underwriting travel in the United States. For our adventure to São Paulo we'd like to thank Nessia Pope and Isabella Prata, and Edemar Cid Ferreira and Paulo Herkenhoff of the Bienal Internacional São Paulo for inviting us to travel there.

Back in New York, the great efforts of everyone at the Whitney made the exhibition and catalogue a reality: Willard Holmes provided invaluable support for many aspects of the project and its exigencies; Constance Wolf planned public programs and educational events; Christy Putnam, Nancy Harm, and Maura Heffner handled the transportation of the art works expertly; Lana Hum finessed the details of our installation design; and interns Linda Fischbach and Glenn Phillips assisted with many details of the project.

Mary E. DelMonico, Sheila Schwartz, Nerissa Dominguez, Heidi Jacobs, Sarah Newman, and Brian Hodge worked miracles to produce the catalogue and related materials with us. We would also like to congratulate Mary on the birth of her daughter just as the catalogue was going to press. From West and East Coasts respectively, Lorraine Wild and Barbara Glauber collaborated long-distance to develop a design that boldly and sensitively underscores the concerns of our project.

The book is greatly enhanced by Douglas Blau's special project. Blau mined his precious and extensive archive to create an eloquent and engaging picture narrative which is the book's surprise and crowning glory.

To mark this last Biennial of the millennium, our close mutual friend and talented publisher Julie Sylvester worked with a number of the participating artists

to make a spectacular portfolio of limited-edition prints. We would like to thank them all for their enthusiastic collaboration and generosity.

No Biennial would be complete without opening festivities. We extend our appreciation to Jon Diamond, William Rudin, and Naomi Kaldor for their generosity in providing the resources, time, and space to make this important event even more memorable.

We are especially grateful to all the lenders whose cooperation we depended on to make the exhibition possible. In particular, we'd like to acknowledge those who helped with loans of complex installations: Peter Noever, director, and Daniela Zyman, curator, at the MAK-Österreichisches Museum für Angewandte Kunst, Vienna, who assisted in bringing Chris Burden's *Pizza City* to New York; Kathy Halbreich, director, and Richard Flood, chief curator, at the Walker Art Center, Minneapolis; Rochelle Steiner, associate curator at The Saint Louis Art Museum; Iwan Wirth at Galerie Hauser & Wirth, Zurich; Peter and Eileen Norton and their assistant curator Bill Begert; and Emilia Kabakov. We would also like to thank the dealers and their staffs for supplying us with information and visual material for use in the catalogue and assisting us with loans.

Lastly and most importantly, we'd like to thank the artists for their inspired collaboration and remarkable works which made it possible to construct the world of this exhibition.

The "1997 Biennial Exhibition" was organized by Lisa Phillips
and Louise Neri, curators; Irene Tsatsos, exhibition coordinator; and
Jenelle Porter, senior curatorial assistant.

This publication was organized at the Whitney Museum by
Mary E. DelMonico, Head, Publications; Sheila Schwartz, Editor;
Nerissa Dominguez, Production Manager; Heidi Jacobs, Copy
Editor; Sarah Newman, Assistant; Brian Hodge, Assistant/Design;
and Soonyoung Kwon, Intern.

Design: Lorraine Wild and Barbara Glauber
Production Assistance: Beverly Joel and Ninotchka Regets
Printing: Meridian Printing
Binding: Riverside Book Bindery
Printed and bound in the USA